DAUMIER

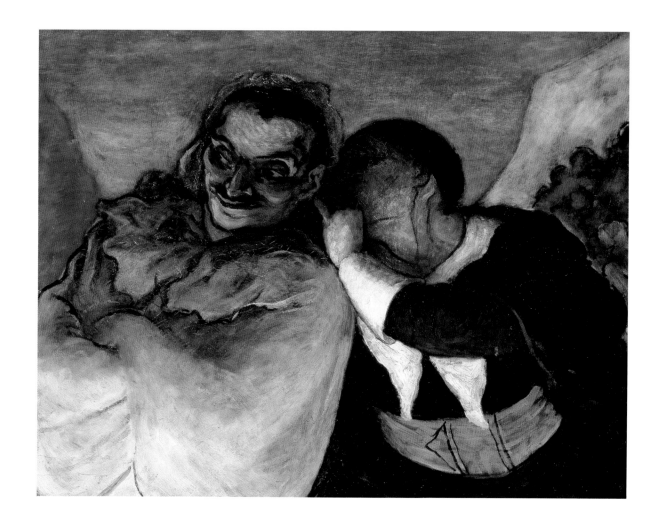

PUBLISHED BY CHAUCER PRESS
20 BLOOMSBURY STREET, LONDON WC1B 3JH

ISBN 1904449239

A COPY OF THE CIP DATA IS AVAILABLE FROM THE
BRITISH LIBRARY UPON REQUEST

DESIGNED BY POINTING DESIGN CONSULTANCY

IMAGE ACKNOWLEDGMENTS:
BRIDGEMAN ART LIBRARY
AKG LONDON

THIS BOOK, EDITED BY CHRISTOPHER WRIGHT,
IS A REVISED AND UPDATED VERSION
OF AN EDITION FIRST PUBLISHED IN 1979.

PRINTED IN CHINA BY SUN FUNG OFFSET BINDING CO. LTD

(FRONTISPIECE)
ETIENNE CARJAT
PHOTOGRAPH OF DAUMIER
CAMBRIDGE (MASSACHUSETTS), FOGG ART
MUSEUM (BEQUEST OF META AND PAUL J. SACHS). 1861.
SIGNED BY DAUMIER BOTTOM LEFT: H.DAUMIER.
THE ARTIST WAS ABOUT FIFTY-THREE AND HAD JUST LEFT THE STAFF OF *LE CHARIVARI.*

DAUMIER

SARAH SYMMONS

CHAUCER PRESS
LONDON

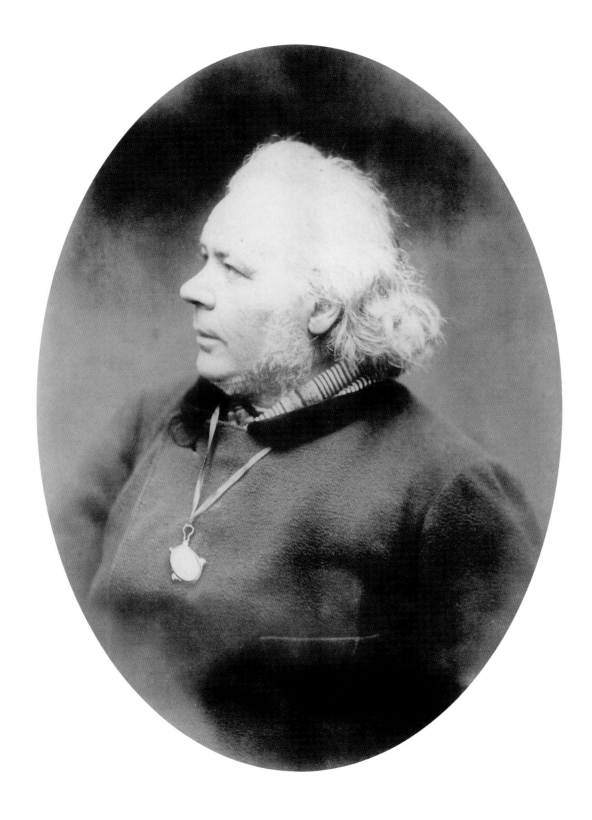

HONORÉ DAUMIER

IN FEBRUARY 1879, at the country village of Valmondois some twenty miles to the north of Paris, 200 people attended the funeral of Honoré Daumier. Among the mourners were the critics Castagnary and Champfleury, the photographer Nadar and the artists Jules Dupré and Geoffroy-Dechaume. The following day accounts of the ceremony appeared in several Paris newspapers. *Le Voltaire* even published André Gille's graveside elegy which included the words: 'It is not strange that we should admire you, and Posterity will say with me: your genius equals the greatest masters of antiquity . . . Like the ancient Roman, painter and sculptor of the gods who was also blind . . . you have built for the sinful an eternal pillory, under the pretence of creating a comic masquerade for the vulgar, and have become the successor to Rabelais, Voltaire and Aristophanes.' Such hyperbole was standard; at least twenty-five obituaries of Daumier appeared in which the writers made extravagant comparisons between Daumier and Raphael, Rembrandt, Holbein and Michelangelo.

A year before he died, while desperately ill and undergoing an unsuccessful eye operation, Daumier held his first one-man exhibition, mounted in the gallery of the dealer Durand-Ruel. Here the public and critics were able to see a part of Daumier's work previously known only to few. The notorious newspaper caricaturist, the satirist of politics under Louis Philippe and lampooner of Second Empire Parisian *moeurs*, Daumier now appeared as a highly original painter. 140 drawings and watercolours and ninety-four oils, as well as some small pieces of sculpture and a changing selection of caricatures, all aroused critical enthusiasm. Daumier's first biographer, Arsène Alexandre, whose book appeared in 1888, traced more than twenty favourable reviews of the exhibition. On view for the first time were some of Daumier's most memorable subjects: figures at work in the streets of Paris (Plate 54); family scenes (Plate 63); washer-women (Plate 57) and one allegorical painting of *The Republic* (Plate 15). Daumier's scope impressed many critics: on comparing the paintings and drawings with the well-known lithographs, they concluded that the caricaturist's skill had enabled him to capture a vivid impression of French nineteenth-century life through the most economical means. But this also entailed a discussion of the more popular

fig. 1 Paul GAVARNI (pseudonym of Guillaume-Sulpice Chevalier)
Figure Drawing
New Haven, Yale University Art Gallery (gift of Frank Altschul). c. 1840.
Pencil 28·5 x 22·7 cm. Unsigned.

This study for a lithograph in a series entitled *Petites causes célèbres* appeared in the one and only edition of the magazine *La Correctionale* in 1840. Gavarni's graphic style is unlike the famous 'nervous' hatching of Daumier's drawings, but here the subject anticipates Daumier's popular courtroom scenes (Plates 21–30), and the caption for Gavarni's design is as memorable as any which accompanied Daumier's legal lithographs. 'It's all lies! . . . And besides, I couldn't have given him a pair of underpants, seeing as how a real lady wouldn't even know about such garments! . . .' ['C'est une fausseté! . . . D'ailleurs je ne lui aurais pas donné un caleçon, vu qu'il n'est pas honnête qu'une femme connusse ce vêtement!']

cartoons and of Daumier's status as a caricaturist. Few critics seemed willing to analyse the private work without also referring to the artist's public success.

Having produced 4000 satirical lithographs and 1000 woodcuts for newspapers over a period of more than thirty years, Daumier's reputation was established. He was ranked with the greatest French wits, including even Molière. 'Before everything else Daumier is a caricaturist', wrote the art critic of the artist's own newspaper, *Le Charivari*. 'He is not really at all inventive [Il n'y est point créateur]' wrote Duranty in the *Gazette des Beaux-Arts*. For these writers the rôle of a caricaturist was a noble one, conjuring up the image of a fearless campaigner battling against unjust authority. Champfleury too made Daumier the hero of his book *Histoire de la caricature moderne*. There Daumier is represented as a martyr to the cause of the liberty óf the press and the freedom of speech. Daumier's lithograph of 1832, *Gargantua* (Plate 1) which had provoked instant reprisal from the government, earning the artist six months in prison, had become part of a nineteenth-century legend. The artist's notoriety was exploited even by his own editor. But Daumier had turned to caricature out of necessity rather than choice, and although caricature gave the greatest delight to the nineteenth-century audience, it was sometimes felt that a taste for the grotesque could undermine the development of serious art. Etienne Délécluze, a pupil of the neo classical French painter David, wrote in the *Journal des Débats* in 1849: 'One of the most lively and realistic types of art is *caricature* . . . and the names of Gavarni [fig. 1], Daumier and Cham have been ranked with those of the most eminent artists of our epoch . . . but I consider that the development and success of caricature in France has coincided with the doctrine of *ugliness*, introduced around 1826 . . . a type of equality and fraternity . . . giving unlimited freedom to painters and poets who now

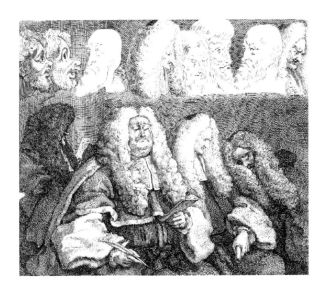

fig. 2 William HOGARTH
The Bench
London, Chiswick, Hogarth's House. Published 4 September 1758. Etching and engraving 21·6 x 21 cm. Unsigned.

There are six states of this, one of Hogarth's last designs, as well as an oil in the Fitzwilliam Museum, Cambridge. Daumier's pictures of judges and barristers, produced about a hundred years after Hogarth, seem to inherit many of the grotesque qualities developed by the English artist (Plates 26 and 28).

have the right to throw the beautiful and the ugly into their works with disdainful impartiality, according to whatever effect they wish to produce.' Even those critics most enthusiastic about Daumier's work in 1878 unconsciously maintained this attitude by ranking his skill as a satirist above his serious, painterly gifts.

Daumier himself was totally uncompromising about his position. In his passport application form of 1849 he entered his profession as that of an 'artist painter' (*'artiste peintre'*). 1849 was the year when Daumier first exhibited at the official Salon with a painting *The Miller, his Son and their Ass* (Plate 18), a fable from La Fontaine. A few literary subjects appeared at the artist's 1878 exhibition, but the majority of his pictures portrayed figures in everyday situations, where a striking contrast appears between the artist's private and public work. In his caricatures few genuine emotions are shown by the characters, who play out the comedy of nineteenth-century Parisian manners. Real tragedies are few; young lovers and elderly spinsters, blue-stockings and feminists (Plates 51–53), unsuccessful painters (Plate 42) and pompous business men all form the raw material of Daumier's cartoons. Time and again the spectator is confronted by the ugly, the inadequate, the hypocritical, the pretentious: lawyers, doctors and politicians (Plates 21 and 22–30), and people showing off their knowledge of art and literature (Plate 47). On the other hand, in Daumier's water-colours and oils, the negative reflection of such lampoons dominates the most ordinary subjects. Helpless fathers coping with monstrous babies (Plate 62) and the wretched travellers whose journey turns into a nightmare (Plate 76) are transformed by the artist into down-trodden people who display a sense of deep anxiety. In caricatures such figures seem awkward and insecure, standing uncertainly, in ill-fitting clothes; they are always hurried or overburdened. These

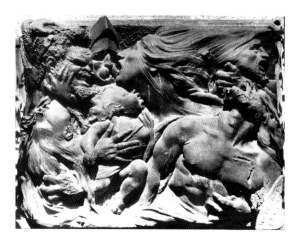

fig. 3 Antoine-Augustin PRÉULT
The Massacre (*Le massacre*)
Chartres, Musées Municipaux. 1834. Bronze relief 109 x
139·7 cm. Signed and dated on right: Aug Preault 1834.

The original plaster model for this relief was exhibited at
the Salons of 1834 and 1850. Daumier and Préault were
close friends and the painter apparently kept a copy of
Préault's *Les parias* in his studio, according to Théodore de
Banville, who saw it during a visit to Daumier in the late
1840s. Here the violent foreshortening of the figures recalls
Daumier's *Rue Transnonain* (Plate 11) and Préault's subject
also anticipates something of the urgency of Daumier's
own sculptured relief of *The Emigrants* (Plate 84).

traits are insinuated into the paintings giving them a tragic monumentality. It is this which makes
Daumier the most pessimistic artist of the nineteenth century. The caricaturist's jaunty cynicism
or the grandiose candour of the journalist has no place in these works. The subjects which appear
so often in Daumier's personal pictures show lonely, overworked women with clinging children
(Plates 54 and 55), terrified fugitives and destitute emigrants (Plates 83–85), unsuccessful street
musicians (Plates 33, 34 and 40) and poor artists (Plate 45). Daumier painted a bitter,
depressing world inhabited by solitary, shabby figures, where poverty and failure are always present.

Daumier's life reveals a similar rootlessness and sense of uncertainty. His ambitions to become
accepted as a serious painter seem to have come to nothing, despite encouragement and even one
or two commissions. He was continually beset by money worries and spent his life moving in and
out of rented rooms, only finding a home of his own at the end of his life. An attempt at
independence as a free-lance commercial artist in 1860 was unsuccessful and Daumier returned to
Le Charivari in 1863. Ironically he began to achieve success as a painter just when he was going
blind and unable to paint at all. His only child died in infancy, not long after he had married the
mother. Apart from the offer of the Légion d'honneur in 1870, which he refused, and a
government pension, bestowed tardily some eighteen months before he died, there was little
official recognition.

Even as a child Daumier was dogged by family problems of fecklessness with money and
absurd ambitions. Both came from his father, a glazier with literary pretensions, who brought his
family from Marseilles to Paris in 1816 hoping to become a famous poet. Spectacularly untalented
himself, Jean-Baptiste-Louis Daumier did his best to bar an artistic career to his son Honoré, who,

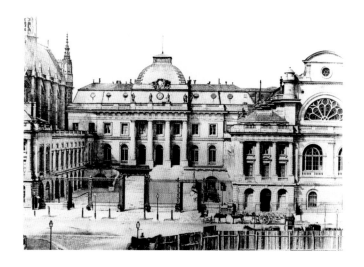

fig. 4 Nineteenth-century photograph of the Palais de Justice, Paris (by courtesy of the Courtauld Institute of Art).

This photograph shows the main staircase and courtyard, Cour de Mai or Cour d'Honneur. The railing, erected in 1787, was restored in 1877. The staircase itself appears in two of Daumier's most famous designs (Plates 23 and 25).

at the age of twelve or thirteen, was already helping to support the family. He worked first as an errand boy and then in a bookshop in the Palais Royal. Daumier did not leave home until he was twenty-five and, in view of the circumstances, the dramatic account of his arrest which appeared in *La Caricature* in August 1833 is perhaps unintentionally, yet revealingly, ironic: 'At the moment we write these lines, they have arrested before the eyes of his mother and father, of whom he is the sole support, M. Daumier, condemned to six months in prison for the caricature of Gargantua' (Plate 1). In a letter written to an artist friend, Jeanron (see Plate 8), Daumier made several caustic remarks about his family: notably that despite prison life and the disturbances caused by the other prisoners, he was able to work better while in detention than at 'Papa's'. After his release in 1832 Daumier did not return home, but moved to his first lodgings in the rue Saint-Denis. Famous as the best caricaturist on Philipon's newspaper *La Caricature*, Daumier seems to have had little difficulty in finding permanent employment. He remained with Philipon, working full time on *Le Charivari* after *La Caricature* closed down in 1835.

Daumier's main reason for remaining a cartoonist was financial: depending upon how regularly he could place designs a talented draughtsman could earn a fair income in the nineteenth century. Daumier worked for *Le Charivari* for most of his professional life, making extra cartoons for other papers such as *Le Journal Pour Rire* (*Journal Amusant*). He produced two or three lithographs a week for each of which he received between forty and fifty francs. A contract dated February 1839 between Daumier and Dutacq, who succeeded Philipon as the owner of *Le Charivari*, shows how profitable the work could be. The artist was guaranteed employment for a period of from six to nine years, producing two or three lithographs a week at fifty francs a design. A down payment in

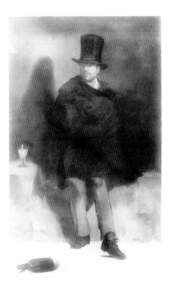

fig. 5 Edouard MANET
The Absinthe Drinker (*Le buveur d'absinthe*)
Copenhagen, Ny Carlsberg Glyptotek. 1858–59.
Oil on canvas 181 x 106 cm.

This painting was rejected at the Salon of 1859. Manet used the figure again in several drawings and engravings and reintroduced him into another painting, *The Old Musician* (Washington, National Gallery of Art). Even contemporary spectators noticed the affinity between this work and the imagery of Daumier (Plates 74 and 75).

advance of 2000 francs towards the first 200 prints was also agreed. On 30 September 1843, when *Le Charivari* was probably losing money, Daumier signed another contract agreeing to reduce his price to forty francs a design, on two conditions: namely that the first eleven lithographic stones should be valued at the old price of fifty francs, and that the reduction would only operate for as long as Dutacq remained owner of *Le Charivari*. According to the English periodical *Fraser's Magazine*, which published a report on the French press in January 1838, the total staff of the average Paris newspaper, including editors, subeditors, contributors, and foreign and home correspondents, received between them the yearly salary of about £2860 or approximately 71,500 francs (between c. 1830 and c. 1870 there were twenty-five francs to the English pound). In a country where the average national wage was about 900 francs per annum and most workers received between two and four francs a day, Daumier's income from caricature was scarcely insufficient.

Yet the artist seems to have gone bankrupt at least once in his life and was constantly borrowing money from friends. In 1831, 1842 and 1862 he was heavily in debt and had his furniture and belongings removed or sold by public auction. The 'bare studio' of the quai d'Anjou where Daumier lived for almost twenty years aroused the imagination of a young poet, Théodore de Banville, when he visited Daumier in the 1840s. He described the ascetic atmosphere; how the only furniture was a few benches, a stove, a table and a lithograph copy of a work by Préault (fig. 3). Banville was a nuisance, a comparatively well-off writer of mainly light verses who pestered Daumier for cheap designs. However it is from the accounts of witnesses like Banville that we learn how Daumier apparently disliked designing for newspapers. Nevertheless, Banville eventually persuaded Daumier to make a decorative headstrip for his newspaper *Le Corsaire* for 100

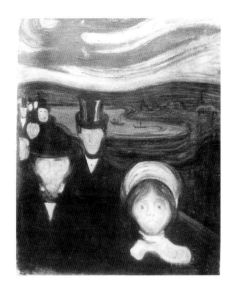

fig. 6 Edvard MUNCH
Anxiety
Oslo, Munch Museet. 1894. Oil on canvas 94 x 74 cm.

The thick lines of paint make the figures similar to
Daumier's *Crispin and Scapin* (Plate 39), and the man in
the top hat became as important to Munch as he did to
Daumier (Plate 75), and to Manet (fig. 5). Here the
figures are not unlike Daumier's series of fugitives
(Plates 83–85).

francs, despite Daumier's initial refusal, pleading his own laziness and the boredom of such a task as an excuse. The evidence of the artist's life suggests that newspaper work was worthwhile, if only because it was well-paid and took little time and trouble. Daumier never seems to have made preliminary drawings for his lithographs and rarely had much to do with the captions. Numerous redundant prints exist without captions, never used by the newspaper, and they imply that Daumier simply drew one or two figures in an appropriate situation, according to a given theme, and the editors of *Le Charivari* then added the text. Consequently it is difficult to know what Daumier really felt about the subjects he depicted. The political views often attributed to him because of the contents of his lithographs probably reflect editorial policy rather than the artist's private opinions.

Charles Philipon, the first owner of *Le Charivari*, also founded the ill-fated *La Caricature* and, in fact, seems to have made a lot of money running 'opposition' newspapers in the nineteenth century. He took every opportunity of capitalizing on clashes with the authorities and printed satirical accounts of them in the very paper which was under fire. Caricatures were essential to these periodicals and Philipon opened the new daily *Le Charivari*, in 1832, very much in the spirit of the older weekly *La Caricature*, which finally closed two and a half years later. The title page of *Le Charivari* promised: 'Caricatures (when the censor allows them) . . . and a new lithograph every day by a leading artist'. Although professing to attack the bourgeoisie, *Le Charivari* was actually one of the most expensive newspapers in Paris, which meant that it had a fairly exclusive circulation. Nevertheless it survived throughout the nineteenth century under various editors, and the only government which succeeded in closing it down entirely (although temporarily) was that of the

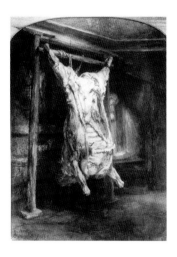

fig. 7 REMBRANDT van Rijn
Carcase in a Butcher's Shop
Paris, Musée du Louvre. 1655. Oil on panel 94 x 68 cm.
Signed and dated bottom left: Rembrandt f. 1655.

This painting was acquired by Napoleon III for the Louvre
in 1857 for 5000 francs. Delacroix and Bonvin were
among the many nineteenth-century French artists to copy
it, and Daumier put a very similar carcase into one of his
own watercolours of a butcher's shop (Plate 73).

Paris Commune in 1871 (see Plate 14). *Le Charivari* was not dedicated to the kind of violent political satire which had made *La Caricature* notorious but even after its closure all the issues of *La Caricature* were bound in four volumes and advertised for sale in the advertisement columns of *Le Charivari* at 104 francs the set.

By stating that *Le Charivari* was a 'theatrical and miscellaneous' daily which published serious theatre and Salon reviews, Philipon cunningly avoided having to pay 'caution money', that is, a deposit paid by all the political journals in Paris. Unofficially *Le Charivari* was classed as a 'paper of violent opposition', but its association with the arts somewhat diluted the dissident opinions expressed on its pages, and ensured a steady income. The lithographic illustrations were not always caricatures but showed many different, popular subjects: views of Paris streets, landscapes, portraits and small everyday scenes. They too were advertised for sale in *Le Charivari* by the printer Aubert, and were bound into albums with titles like: *Paris in Miniature* or *An Album of Sportsmen* or *Medical Caricatures*. The artists who worked regularly for the paper were Grandville, Forest, Arnoult and Gavarni (fig. 1), whose subjects often resemble those treated by Daumier. Philipon himself was an accomplished designer who made an enormous profit out of a famous caricature of Louis Philippe as a pear. The ensuing prison sentence Philipon received for his lampoon only increased the price of the design and, in 1834, when advertising Daumier's *Rue Transnonain* (Plate 11), Philipon made sure that both the price and the fact that this was a controversial subject were emphasized in the accompanying text. After the censorship law of 1835 (see Plates 10 and 12) the illustrations of *Le Charivari* concentrated mainly on everyday satires and Daumier's lithographs provided the core of many albums. It is probably from this increasing sale

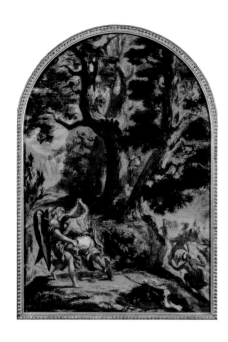

fig. 8 Eugène DELACROIX
The Fight between Jacob and the Angel (La lutte de Jacob avec l'ange)
Vienna, Kunsthistorisches Museum. Oil on canvas 57 x 41 cm.
Signed bottom left: Eug. Delacroix.

This sketch is a study for the mural completed in 1861 in the
Church of Saint-Sulpice in Paris. The composition of this work
may have influenced Daumier's picture *The Thieves and the Ass*
(Plate 20), which was based on a story from La Fontaine.

of prints that Daumier's reputation continued to grow in Paris in the nineteenth century and from
the wide circulation of albums of lithographs, which continued long after the print had originally
appeared in the paper.

One of Daumier's warmest admirers was Charles Baudelaire whose poetry reflected an interest
in many subjects identical to those in Daumier's repertoire. Baudelaire himself often drew
inspiration from nineteenth-century Paris, inhabited as it was by picturesque figures of poets,
widows, ragpickers and workmen (Plates 54, 73 and 75). He also found a heroic intoxicating joy in
the city and delighted in its landscape of rooftops and in the great, noisy, bustling crowds. In his
famous essay 'The Painter of Modern Life' ('*Le peintre de la vie moderne*'), written c. 1859–60,
Baudelaire imagines the life of an artist working in the middle of these surroundings, and using as
subject matter the most trivial, contemporary details. Significantly, Baudelaire chose as his
example an artist who worked for newspapers, Constantin Guys. In the essay Guys becomes 'the
painter of modern life', ceaselessly at work, too busy to go to bed, 'distilling the immortal from
the ephemeral', as Baudelaire describes his activity; an artist who makes the trivia of daily existence
memorable, from the most outrageous fashions to street parades and all-night cafés.

Many of Baudelaire's observations about Guys could also apply to Daumier. He too worked
ceaselessly, often at night, noting down the distinctive, idiosyncratic elements of life around him;
he too endowed his figures with an epic heroism. Daumier seems to participate in Baudelaire's
ambivalent emotions of excitement and horror as he surveys the city. The poet's euphoric
descriptions of Paris, people dressed in top hats, frock coats and crinolines, the cabs and the
workmen, are paralleled by his poems about poverty, failure and distress which are as moving as

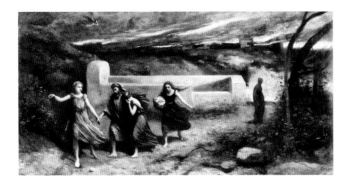

fig. 9 Jean-Baptiste-Camille COROT
The Destruction of Sodom (L'incendie de Sodom)
New York, Metropolitan Museum of Art (bequest of Mrs H. O. Havemeyer). 1843–57. Oil on canvas 925 x 181·3 cm. Signed bottom right: Corot.

Refused at the Salon of 1843 and accepted in 1844, this painting was exhibited again in 1857 after the artist had altered it. Corot's influence on Daumier's work was considerable, as was the friendship between the two artists, and according to many of Daumier's biographers, it was Corot who bought Daumier his house in Valmondois when Daumier began to go blind. This painting may have had a profound effect on Daumier when he began to paint the series of paintings of fugitives, and it anticipates particularly Daumier's depiction of fleeing or emigrating figures in a painting in Winterthur (Plate 83).

Daumier's paintings *The Heavy Burden* (Plate 54) and *The Nightstrollers* (Plate 75). Both poet and painter lived for a time in the same part of Paris, on the Ile Saint-Louis, and often they depict its landscape: the steep embankments of the Seine surrounded by rows of old-fashioned apartment buildings (Plates 57 and 75). Just as Daumier could turn from a drawing of an amusing scene in an omnibus (Plate 77) to a tragic widow leaving the Palais de Justice (Plate 24) or a washerwoman climbing the steps of the quai d'Anjou (Plate 57), similarly Baudelaire could look at Paris with repulsion. 'Dreadful life! Dreadful city! [Horrible vie! Horrible ville!]' he intones in a poem entitled *One O'Clock in the Morning*. In this, the poet, harassed by the tensions of city life, consoles himself with the hope of writing a perfect poem. Written some time after the exuberant essay on Constantin Guys, this poem may be contemporary with some of Daumier's darker works in which life becomes a strain (Plate 33), people are dispossessed (Plate 84) and a sense of anxiety pervades the hurrying crowd (Plates 83 and 85). It is possible to see Manet's painting of *The Absinthe Drinker* (fig. 5) developing out of the archetypal stroller (Plate 75) or the rarely-depicted poor drunk (Plate 74) immortalized by Daumier. And the image of the threatening city, of processions of anxious people, was inherited by Edvard Munch whose twisted, streaky brushwork is as sinister as Daumier's (fig. 6).

As a painter, Daumier was probably self-taught. His use of oil paint was unorthodox and sometimes disastrous. Unfortunate mixtures of pigment and media and mysterious preparations have caused immense damage to some paintings (Plate 17). In others, figures or details may be lost beneath suppurating bitumen (Plate 21). Sometimes unknown forgers or copyists carefully completed Daumier's unfinished works, and one or two quite famous paintings are now known to

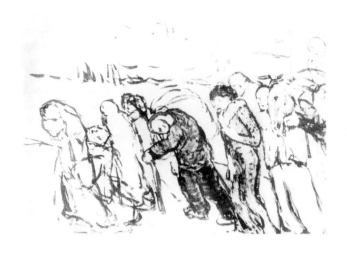

fig. 10 Pablo PICASSO
The Fugitives
Paris, private collection. 1901.
Oil sketch 73 x 56 cm. Unsigned.

Daumier's Winterthur painting of *The Fugitives* (Plate 83) was exhibited in Paris in 1900, and again in 1901, and it could well have inspired this sketch by Picasso.

have been entirely repainted by anonymous hands. By the end of the nineteenth century it was fashionable to forge Daumiers because the artist's idiosyncratic style with its wobbly outlines and thickly painted ridges was easily recognized, and could provide a technical challenge to the ambitious amateur. It is difficult to date the artist's private work because, unlike most major painters, Daumier seemed to have changed his style very little so there are no convenient 'periods' to be analyzed. Because he did not sell or exhibit paintings on a regular basis it is impossible to know when he finished them. Many pictures probably remained in the corner of his studio for years and he may have retouched them occasionally or left them for other people to finish. The rare recorded commission (Plates 77–79), a painting given to a friend to cover an unpaid debt, or a visitor who happened to mention seeing a picture in a half-completed state (Plate 54) is all the evidence which exists so far for dating many of Daumier's works. The few occasions when the artist exhibited at the Salon and the effect of encroaching blindness on his style offer the only chronological certainties; the other datings must be conjectural. A few extant letters and one or two accounts add a little information. Modern technical experiments also offer a few vital clues about the development of the artist's style, but even these often form paradoxical conclusions.

Although Daumier could apparently draw with enormous facility straight onto a lithographic stone, x-rays of certain works show that he found painting extremely difficult. A thick concentration of lines usually burrows beneath the craggy surface of the paint as if the artist had constantly changed his mind. The familiar range of gesture and expression which was instantly available to him for newspaper designs did not suit the demands of painting. In prints even contemporary observers noticed how consistently Daumier used contrasting scales and types of

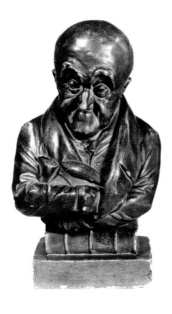

fig. 11 Jean-Pierre DANTAN
Caricature Bust of Samuel Rogers
London, National Portrait Gallery. 1833.
Plaster 31·2 cm. high. Inscribed: Published by Dantan . . . [illegible] London.

Dantan's caricature busts were immensely popular in Paris and London during the late 1820s and early 1830s. They may have influenced Daumier's own caricature busts (Plate 4).

figure and detail, from the earliest cartoons (Plate 12) to the later scenes from the Franco-Prussian war (Plate 14). In painting, however, Daumier may have felt obliged to construct a new set of figure conventions, although he never entirely altered his composition. His subject matter was limited to human activity, more or less excluding still-life and landscape except as background details, but even in classical works, *Two Nymphs Pursued by Satyrs* (Plate 17) or the fable from La Fontaine *The Thieves and the Ass* (Plate 20), he used the sharp gap between foreground and background which appears in lithographs such as *The Freedom of the Press* (Plate 10); often he blocked out the background entirely as in *Rue Transnonain* (Plate 11) and *The Drunkenness of Silenus* (Plate 16). Although he usually began a painting by covering a panel or canvas with the same nervous, rippling lines that appear in the graphic work, his painted figures are starker and more austere than those of the prints. He would work towards a simplified image, discarding details as he painted, but always retaining the surface animation. Consequently he most admired and copied those artists who also painted in fluid, thick strokes or blocks; he evidently learned much from contemporaries like Delacroix or Corot (figs. 8 and 9) but, as a frequent visitor to the Musée du Louvre, Daumier also found inspiration in the paintings of Fragonard, Rubens and Rembrandt (fig. 7).

When translating these images into paint Daumier worked unconventionally, almost eccentrically. The economy of his drawings, praised by many critics, influenced the painting and makes the pictures seem extraordinarily modern. He developed a tendency to place sections of a figure or object slightly apart, telescoping details into compact masses. By nineteenth-century standards of finish his paintings looked quite wrong and rather crude. The primitive qualities of

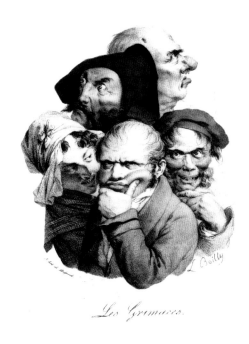

Les Grimaces.

fig. 12 Louis-Léopold BOILLY
Ugly Men and a Young Girl
London, British Museum, Department of Prints and Drawings.
1823–28. Lithograph 35 x 26·5 cm. Signed bottom right: L. Boilly.
This is number seven from Boilly's famous *Receuil des grimaces.*

some of the serious pictures may have come from his habit of redrawing a form and always simplifying it so that the final effect reached a strange kind of personal shorthand. Daumier's apparent inability to finish anything made him a bad risk for anyone commissioning works of art, and he left a trail of unfulfilled government commissions behind him from 1848 to 1863 (Plates 15 and 16). Nevertheless, it is difficult to reconcile any traditional idea of 'finish' with Daumier's painstaking move towards absolute stark simplicity in painting. In the large picture *We want Barabbas!* (Plate 19) the figures in the foreground have a constriction of detail which is not clumsy but probably was a calculated effect: they become mask-like, expressive, and perhaps anticipate much later experiments in religious art. It is difficult not to think of a painting like James Ensor's *Entry of Christ into Brussels in 1889* (Knokke-het-Zoute, Casino Communal, 1888) where the crowd is a sinister collection of carnival masks, or Emil Nolde's reduction of faces and forms to crude dark outlines in religious works of 1910–12. And it is not surprising that Picasso (fig. 10), Steinlen and Paul Klee also looked carefully at Daumier's work when constructing their own expressive styles. For Daumier himself, the experimental quality of his painting may have undermined his chances of official success. The periods of his life when he is known to have been painting constantly include the late 1840s and early 1850s, when he exhibited at the Salon, and the early 1860s when he tried to sell pictures on the Paris art market. Perhaps it is significant that during this last period the works he produced for sale were mainly watercolours, many of which derived from earlier, successful lithographs and were, consequently, more 'finished' in appearance (Plate 25).

Writing in his review of the Salon of 1845, Baudelaire praised Daumier's graphic techniques and ranked the caricaturist with the classical painter Ingres as probably the two best draughtsmen in

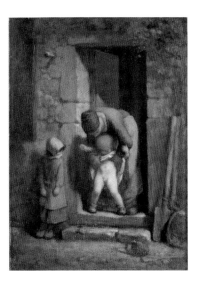

fig. 13 Jean-François MILLET
Maternal Care (La précaution maternelle)
Budapest, Szépmüvészeti Múzeum. 1855–57.
Black crayon 29·7 x 21·5 cm. Signed bottom right: J.-F. Millet.

In 1856 Madame Daumier became godmother to Millet's son François. Daumier may have known of Millet's drawings of domestic scenes, because this composition would seem to have influenced Daumier's development of the subject of *The First Bathe* (Plates 63 and 64).

Paris. Although Daumier's work was quite different from that of his academic contemporary, he frequently parodied the subjects which Ingres painted so brilliantly: classical Greek and Roman stories provided *Le Charivari* with an hilarious series of cartoons, *Anciens héros* (1841–43) and *Physiognomies tragico-classiques* (1843). Sometimes there is even a hint in Daumier's caricatures that the bourgeois ladies and gentlemen in funny situations have the same kind of solid figures which Ingres made into renowned portraits (Plate 57). Baudelaire's comparison is therefore extremely perceptive. Daumier too had a classical draughtsman's training in the early 1820s when he had studied with Alexandre Lenoir, the director of the Musée des Monuments Français in Paris. Ingres himself had worked in this museum and known Lenoir many years before. Daumier left Lenoir and went to work in the Académie Suisse and later took up an apprenticeship with the lithographer Béliard in 1825, but traces of classical draughtsmanship remained in his work. It appears particularly in his drawings and paintings of horsemen (Plates 65 and 66) whose firm contours recall the lines of riders on ancient bas-reliefs. It may have been this classical bias in Daumier's drawings which enabled him to reduce figures and faces to their essential components. Baudelaire's 'The Essence of Laughter' which included an article on French caricaturists noted Daumier's razor-sharp precision, his observation of the way in which a 'bourgeois' talked to his wife or the portrayal of the shape of a nose or skull which enabled the spectator to sum up instantly the character. Every detail of such drawings is important. In fact, Daumier's pictorial characterization of the inhabitants of Paris between 1830 and 1870 is often regarded as analogous to the literary creations of Balzac and Flaubert. In Balzac's series of novels *La comédie humaine*, begun in the 1830s, a distinct hierarchy of type and personality appears, motivated and classified

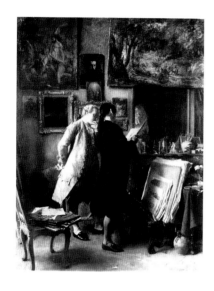

fig. 14 Jean-Louis-Ernest MEISSONIER
An Artist Showing his Work
London, Wallace Collection. c. 1850s. Oil on panel 39 x 30 cm.
Initialled between legs of left figure: E.M.

Possibly exhibited at the Salon of 1857, this small panel is
typical of Meissonier's most popular works. Daumier's own
pictures of artists and connoisseurs are occasionally reminiscent
of Meissonier's although Daumier's treatment of paint is less
meticulous, and he always put his figures in contemporary dress
(Plate 44).

according to income and prospects. These characters betray their inner workings through quite
trivial details, such as a certain phrase they use in conversation or a way of doing their hair. In
Flaubert's novel *Madame Bovary* (1856) such details become almost surreal. The characters are
savagely caught by the writer simply by the way they hold a teacup or eat their dinner, by the kind
of newspapers they read or the food they like best. Contemporary admirers of Daumier's cartoons
noticed how the artist used similar techniques. At the 1878 exhibition Duranty observed that the
series of busts which Daumier made in the early 1830s (Plates 4, 6 and 7) derived their expressive
force from the way in which the chins of the subjects disappeared into their collars and cravats.
This same degree of fine observation and detail permeates Daumier's drawings and watercolours,
especially those made in the 1860s for commercial purposes. The skull of a criminal in the dock
(Plate 27) is no less expressive than that of a rather down-at-heel connoisseur who sits in a
mass-produced, spoon-backed nursing-chair, admiring a plaster cast of the *Venus de Milo* (Plate 46);
or the people in the first- and second-class railway carriages (Plates 78 and 79) whose facial
expressions and occupations betray their status. Paintings such as these may be seen as
developments from the art of caricature, just as *We want Barabbas!* (Plate 19) or the Don Quixote
series (Plates 87–92) completely transcend that genre and reach out to a more universal notion of
folly on a grand scale.

By 1829, when Daumier began working on *La Silhouette*, French caricature was already an
accomplished artistic discipline. The distinguished draughtsman Louis-Léopold Boilly
(1761–1845), who worked in lithograph throughout the Napoleonic period, was famous for
producing designs of certain types of facial distortion and Daumier may have known Boilly's

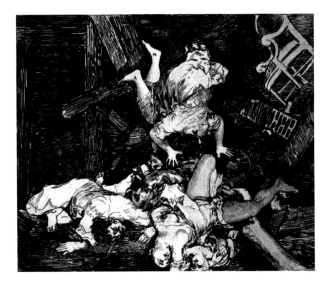

Receuil des grimaces (fig. 12). Parodies of physiognomies and grimaces (Plates 3 and 9) also appear among Daumier's earliest graphic designs, a preoccupation which may have strengthened the expressiveness of the artist's later watercolours. Daumier chose to portray many characters in exaggerated poses: Crispin and Scapin (Plates 38-39) for example, Don Quixote and Sancho Panza and the audience of *The Drama* (Plate 36). But basically the cast of characters which inhabits Daumier's lithographs, drawings and paintings is not large. Women and children appear in many different situations (Plates 50-57) and the self-satisfied, middle-aged man may be a lawyer (Plate 25), a connoisseur (Plate 46) or, with a slight change of outline, an innocent sightseer (Plate 75). The charlatan who became Robert Macaire (Plate 31) will turn up again as Ratapoil (Plate 13) or as a well-known clown (Plate 39). The workman, the shopkeeper and the fashionable lady all assume new personalities with a change of clothes or expression. In Daumier's watercolours the artist re-examined this repertoire, which evidently inherited much of the popularity of newspaper imagery, and made this same cast of characters into more personal depictions.

Many of the subjects Daumier painted can be found on the lists of Salon pictures after about 1850, and among the better-priced items sold by Paris dealers. Daumier seems to have had a reasonably well-developed commercial instinct and he became comparatively successful at the end of his life. However, the artist's prices were haphazard and inconsistent throughout his career and only long after his death, when dealers took more interest in his work, does any pattern of value emerge. In 1875, at the sale of Corot's collection, four oil paintings by Daumier fetched 1500, 1520, 1550 and 1160 francs respectively. These included a famous picture of an *Amateur d'estampes* (Lyon, Musée des Beaux-Arts) and *Les curieux à l'étalage* (Biltmore, North Carolina). In 1876

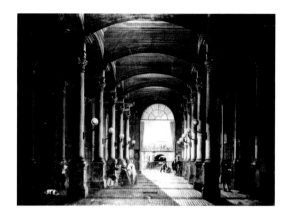

fig. 16 FRENCH SCHOOL
Interior of the Gare Saint-Lazare
Paris, Musée Carnavalet. Oil on canvas 185 x 135 cm.

This view of the Gare Saint-Lazare shows the vestibule of the station before it was remodelled by Lisch in 1886–89. Daumier made a finished watercolour of this same vestibule, probably in the late 1850s or early 1860s (destroyed in the First World War), whence he himself would probably have departed to Valmondois for summer holidays (Plates 76–82).

Daumier himself sold a Don Quixote oil to Madame Bureau for 1500 francs (Plate 90). Yet in 1877 the artist also recorded selling an oil painting of a Molière subject and a watercolour of a painter's studio for 200 francs each. In 1862 he gave a painting to Daubigny to cover a debt of 1500 francs and in 1864 sold watercolours to G. A. Lucas for 100 francs each. Towards the end of his life two dealers showed an interest in his work, Vollard and Durand-Ruel, famous as the first dealers to handle Impressionist paintings, and at the 1878 exhibition only seventeen of the ninety-four oils exhibited were listed in the catalogue as being still in the artist's possession. Just before he retired, Daumier records making over 6000 francs from the sale of paintings, and in 1874 he was able to buy his small rented house in Valmondois for 3500 francs. Nevertheless his popularity with an exclusive group of artists, critics and collectors hardly mitigates the impression of failure and obscurity which clings to his posthumous reputation. Admiring articles by Baudelaire, Champfleury and de Banville appeared in the 1850s, praise from fellow artists as eminent as Delacroix and the rare honour of a one-man exhibition all suggest that Daumier was more esteemed in his own lifetime than is generally accepted. Yet his earliest biographers, aware of Daumier's mysterious indigence and sense of failure, usually ignored the comparatively comfortable last years of the artist's life; even a few of the reviews of Daumier's exhibition and his obituaries were inclined to present the rather melancholic image of a life sacrificed to the pursuit of truth and graphic realism at the cost of personal success and prosperity.

From an analysis of the people who bought pictures from the artist, a pattern does emerge. Daumier's watercolours seem to have suited the small, private collector and his oil paintings particularly fascinated fellow artists. He is in many ways a painter's painter whose work offered

contemporaries a new personal style and a new range of images. Corot, Daubigny, Degas and the sculptor Geoffroy-Dechaume were among his most faithful collectors, but Daumier's pictures also attracted foreign connoisseurs. One or two English and American visitors to Paris perhaps saw his images as expressive of the character of the city. We owe the existence of the marvellous watercolours of the first-, second- and third-class railway carriages (Plates 60, 78, 79) and the omnibus scene (Plate 77) to two Americans whose professional interests were mirrored by the subject. William Walters, the railway tycoon, who moved to Paris during the American Civil War, commissioned watercolours from Daumier through another compatriot, George Aloysius Lucas. Lucas himself was a retired civil engineer from New York who had been in charge of the construction of the Central Railway of New Jersey. His means were limited but he remained in Paris until his death in 1909 and built up a large collection of works by French painters, the majority of whom are now very obscure. Evidently Lucas bought what he could afford and it is revealing that although he possessed only one Delacroix and one Meissonier he owned four Daumiers, including a bronze version of *Ratapoil* (Plate 13). Lucas also collected Daumier's lithographs, as did many other nineteenth-century connoisseurs, and the artist himself was obviously aware of the kind of designs which sold well. In the early 1860s, when he had temporarily ceased working for *Le Charivari* and was desperately short of money, Daumier used the style and themes of earlier lithographs in watercolours. *The Grand Staircase of the Palais de Justice* (Plate 25) is probably the best example of how well a cartoon could be adapted for the purposes of a finished drawing. The market for rare proofs of Daumier's very early lithographs, however, lasted throughout the nineteenth century. In 1851 the artist himself obtained for Michelet two or three of his portrait caricatures, made in the 1830s for *La Caricature* and *Le Charivari* (Plate 6), and in 1894 the painter and engraver Bracquemond proudly displayed to Edmond de Goncourt some marvellous proofs of *The Legislative Belly* and *Rue Transnonain* (Plates 9 and 11) which he claimed to have picked up years before for two sous each.

Although he told Théodore de Banville that he was 'lazier than a thousand snakes', Daumier worked ceaselessly for a period of some fifty years and was extremely prolific. His total output is calculated at 300 paintings and over 800 drawings and watercolours. He probably made about fifty pieces of sculpture although many more small figurines have been attributed to him. The addition of 5000 lithographs and woodcuts means that Daumier completed a new work every two or three days of his adult life, except for the last three or four years when he was blind. His cartoons appeared more or less regularly under several different governments: a constitutional monarchy, an

empire and two republics, and he lampooned scores of politicians. Nineteen years of caricatures printed during the Second Empire, one of the most corrupt, immoral and flamboyant epochs of French history, may have caused Daumier to be hailed as a great crusader, a chastiser of kings and poor men alike, with a strict sense of justice and a piercing eye for hypocrisy. But his private works have their own moral code, one which reaches beyond the historical interest and conventional decorum of the prints and watercolours which so delighted Daumier's admirers. The artist's greatest pictures are sometimes those which seem remote even from the images produced by the contemporary masters with whom he is often compared. Unlike Courbet, Manet, Guys and Gavarni, Daumier did not paint prostitutes or fashionable characters; there are few drunks and no daring cabarets; he had little interest in the sophisticated seediness of Paris which was immortalized so brilliantly by late nineteenth-century painters, and by novelists from du Maurier to George Moore and Zola. Instead Daumier portrayed only the mundane tedium of shoppers, workers or anxious travellers; the isolation of city children and of buskers and stallholders competing for public attention; a vista of narrow streets and steep tenements which sometimes changes into the artificial scenery of the music hall. And he continued to paint such images long after the locations and even the characters had disappeared. In the 1850s and 1860s Baron Haussmann demolished the narrow streets and slum areas of Paris; the rue Transnonain and many streets like it no longer existed during the last twenty to thirty years of Daumier's life. Perhaps it is this sense of constant change which makes his pictures emotionally charged in an almost indefinable way. All Daumier's images have a fleeting, impermanent quality about them, increased by their pictorial clothing of scraggy lines of paint and thin, scratchy drawings. Often regarded as monuments to ordinary, anonymous people, Daumier's works are in fact as elusive as their creator.

APPENDIX

These are some of the periodicals for which Daumier worked:

La Caricature: founded by Charles Philipon, this was a political and satirical paper which was violently against Louis Philippe, and whose caricatures were invariably political and usually fairly libellous. It was founded on 4 November 1830 and closed on 27 August 1835.

La Caricature Provisoire also known as the second series of **La Caricature:** a descendant of the old *La Caricature* but which only satirized Parisian *moeurs*. Founded by Charles Philipon, its editor was Louis Huart, and contributors included Balzac. It ran for nearly three years, 1839–42.

Le Charivari: a contemporary English translation of the title, undertaken by *Fraser's Magazine* in 1838, was 'The marrowbones, cleavers or the hubbub at a dustman's wedding or an Irish wake'. Founded by Philipon on 1 December 1832 as another political magazine, and as a successor to *La Caricature*, it soon changed to everyday satire. Its editors included Louis Desnoyers, Albert Clerc, Louis Huart and Arnaud de Vresse.

Le Corsaire: a literary paper whose contributors included Théodore de Banville, and whose director was Lepoitevin Sainte-Alme, it was founded on 6 February 1822 and closed on 30 September 1852. An off-shoot also entitled *Le Corsaire* appeared in 1858.

Le Journal Pour Rire: a satirical and comic magazine, consisting mostly of pictures and directed by Philipon, it was founded on 5 February 1848 and in 1856 it became *Le Journal Amusant, Le Journal Pour Rire*.

La Silhouette: another caricature journal, and probably the earliest, it was founded by Emile de Girardin and possibly Philipon on 23 June 1829 and closed on 23 January 1831; it ran into 52 issues with 104 plates. Designers also included Gavarni and Henri Monnier, and contributors included Balzac and Varaigne.

Le Temps Illustrateur Universel: was founded in collaboration with *L'Illustration* in June 1860; its editor was Ph. Busoni, and its art editor was Gavarni.

CHRONOLOGY

1808	Honoré Daumier was born on 26 February at Marseilles, son of Jean-Baptiste-Louis Daumier, a glazier and poet, and of Cécile-Catherine Philip.
1814	Leaving his family in Marseilles in great poverty, Jean-Baptiste-Louis Daumier arrived in Paris. In 1815 he published *A Spring Morning*.
1816	In September, Honoré and his mother arrived in Paris.
1819	Jean-Baptiste Daumier produced his play *Philippe II* at his own expense.
1820	Honoré took a job as an errand boy to a tipstaff in order to help his father financially.
1821	The young Daumier worked in a bookshop in the Palais Royal and began drawing.
c.1822	He became a pupil of Alexandre Lenoir.
c.1823–8	He studied at the Académie Suisse.
c.1825–30	He was apprenticed to the lithographer Béliard and began to copy in the Musée du Louvre.
c.1829	Daumier obtained his first newspaper work on *La Silhouette*.
1830	After the July Revolution, Louis Philippe was proclaimed the 'King of the French'. Daumier began to work in sculpture, encouraged by Préault (Plates 4–7), and made his first political caricatures. *La Caricature* was founded by Philipon and Aubert.
1831	Daumier was in serious debt; he produced *Gargantua* (Plate 1).
1832	Daumier was put on trial on 23 February on the charge of having 'perpetrated an outrage against the person of the king'. He was sentenced to six months imprisonment and a fine of 500 francs. On 31 August he went to Sainte-Pélagie prison for political offenders, and on 11 November he was transferred to Dr Casimir Pinel's sanatorium at Chaillot. *Le Charivari* was founded by Philipon on 1 December.
1833	Daumier was released from prison. He decided to leave his parents and live alone. He began to work for *Le Charivari*.

1834	He produced five lithographs for Philipon's *L'Association Mensuelle* (Plates 9–11). In April the massacre in the rue Transnonain took place.
1835	On 29 August, the censorship law was passed. *La Caricature* closed down.
1841	Daumier borrowed 110 francs to pay debts.
1842	Daumier was in serious debt again and had his furniture sold by public auction.
1845	Daumier moved to the quai d'Anjou, and Jean-Francois Millet arrived in Paris.
1846	Birth of a son named Honoré on 2 February. On 16 April Daumier married the child's mother, Marie-Alexandre Dassy ('Didine').
1846–8	His son died. Daumier probably met Baudelaire, Daubigny and Geoffroy-Dechaume at this time.
1847	Daumier and the sculptor Barye tried to organize an independent salon.
1848	Daumier took part in a protest against the inflexible attitude of the official Salon jury (3 February). Louis Philippe was dethroned (18 March). Daumier entered the competition for a sketch of *The Republic* (Plate 15). His sketch was placed among the twenty best but he never finished it. The Salon exhibition was now open to all artists but he failed to exhibit anything. On 19 September, Daumier's friend Jeanron, who had become the Minister of the Interior, paid him 1000 francs to paint a religious picture (see Plates 16 and 19).
1849	On 10 February, the money for the state commission was increased to 1500 francs but Daumier still failed to produce anything, although his Magdalene subject was refused (Plate 16). Delacroix recorded Daumier's difficulties in finishing work in his *Journal*. Daumier and Delacroix became friends. Daumier exhibited *The Miller, his Son and their Ass* (Plate 18) at the Salon.
1850–2	Millet exhibited *The Sower*, Courbet *The Funeral at Omans* and Daumier *Two Nymphs Pursued by Satyrs* (Plate 17), *Don Quixote* (Boston, Paine collection) and *The Drunkenness of Silenus* (Plate 16) at the Salon. In December 1851, Louis-Napoleon's *coup d'état* took place, and he declared himself Napoleon III, 'Emperor of the French', 1852.
1853	Daumier made his first summer visit to Valmondois. He met Corot, Théodore Rousseau and Millet.
1856	Madame Daumier became godmother to Millet's first son François (born 1849).
1857	Daumier was involved with Millet, Diaz, Rousseau and Barye in making illustrations for a new edition of La Fontaine, but the project came to nothing.
1860	He left *Le Charivari*.
1862	Daumier borrowed 1500 francs from Théodore Rousseau. In very bad financial straits he was forced, yet again, to have his furniture auctioned off at a loss.
1863	He left quai d'Anjou, and spent the summer in Valmondois. In December he returned to the staff of *Le Charivari*, and a banquet was held in his honour to celebrate his return.
1865	Daumier left Paris and took a house at Valmondois.
1867	His eyesight began to fail.
1868	According to early biographers, Corot bought Daumier's house in Valmondois and gave it to him, but this is undocumented (see below).
1870	In July Daumier attended a banquet to celebrate Courbet's refusal of the Légion d'honneur, which himself also refused. The Franco-Prussian war began.
1871	The Commune was established. Daumier was elected a member of an artistic commission set up to protect works of art in museums during the siege of Paris; he borrowed 500 francs from Daubigny.
1874	This was the date of the agreement by which Daumier bought his house in Valmondois for 3500 francs.
1877	Almost blind, Daumier was granted a government pension of 1200 francs per year.
1878	On 17 April Daumier's one-man exhibition opened in Durand-Ruel's gallery, under the chairmanship of Victor Hugo, and was favourably reviewed. An operation on Daumier's eyes, which took place at the same time as his exhibition was opened, was unsuccessful.
1879	Daumier died of a stroke in February. He was buried at Valmondois. In April, his remains were transferred to the Père La Chaise Cemetery in Paris.
1894	Madame Daumier died. The studio contents were sold for 1500 francs.

POLITICAL CARTOONS AND CARICATURES

Daumier was probably the greatest caricaturist of the nineteenth century. His influence permeates the work of many other such artists, from Cruikshank in nineteenth-century England to George Grosz working in Germany in the 1930s. His political prints are always recognizable and rarely funny. Sometimes they display the savagery of *Gargantua* (Plate 1) or the moving simplicity of *Hideous Heritage* (Plate 14). Frequently cynical, their impact is now almost lost because they depict the ramifications of obscure contemporary issues and their captions incorporate the street slang of the 1830s (Plate 2), or jargon from the different quarters of Paris.

At the end of Daumier's life, critics preferred to analyze the social prints which the artist made from the late 1830s to the early 1870s rather than his political cartoons. Duranty, for example, reviewing Daumier's exhibition of 1878, asserted that the artist's lithographs were really the work of a social historian interested in portraying the modes and manners of every aspect of French nineteenth-century life. Duranty also pointed out, probably quite rightly, that the captions to Daumier's lithographs were written mainly by the editors of *Le Charivari*, and that the type of political design which Daumier used derived from that of other cartoonists: Charlet, Lamy and Henri Monnier. Castagnary's review in *Le Siècle* also suggested that Daumier's newspaper prints were those of a supreme artistic moralist who knew human nature, but Alexandre, Daumier's first biographer, was struck by the fierceness of the artist's hatreds and enthusiasms, and he maintained that all Daumier's lithographs were political campaigns of some kind. Champfleury too saw Daumier as a master of caricature, using it as a weapon to attack bourgeois and corrupt politicians, and this is the image of the artist which has remained.

Little seems to be known about Daumier's own politics, although it is generally assumed that he was an ardent republican. It must be realized that Daumier's political work expressed the policy of the newspapers for which he worked, and the language of his political imagery developed under the influence of the anti-monarchist press which flourished during the early years of Louis Philippe's reign. One obscure newspaper published at this time was *Le Nouveau Gargantua* which was devoted to attacking Louis Philippe, and its title might have inspired Philipon to

commission from Daumier the lithograph which caused the artist's imprisonment (Plate 1). But Daumier not only caricatured Louis Philippe and his deputies before the censorship law was passed in 1835; he also attacked the provisional government of the Second Republic of 1848, lampooned the mob which broke into the Tuileries Palace during the revolution, and pilloried Napoleon III as Ratapoil (Plate 13).

Changes in Daumier's style of caricature seem to have developed from changes in editorial policy, introduction of new subjects or the vagaries of the censorship laws to which the artist's prints were subject throughout his career. The harshly economical early lithographs (Plate 2) reached a climax in the 1830s with the five designs Daumier made for Philipon's *L'Association Mensuelle*, which included *The Freedom of the Press* (Plate 10) and *Rue Transnonain* (Plate 11). These stark images gave way to the curvilinear outlines of the 'social' scenes produced from the late 1830s to the early 1870s. At the end of Daumier's life his failing eyesight caused him to elongate his figures, but the format he had evolved in the 1830s remained the same: large foreground figures and a sudden drop back to a wide distance. Any particularly vital issue such as the rue Transnonain incident or the Franco-Prussian war (Plate 14) shows Daumier stripping the design right down to its rudimentary components. It is this which distinguishes him from his most famous predecessors in political caricature, Hogarth, Gillray and Rowlandson in England and Boilly (fig. 12) in France; and also from contemporary artists, Gavarni (fig. 1), Forest, Cham and Grandville. Daumier always recognized the effect of pictorial understatement, a quality he shared with Goya (fig. 15), the only other nineteenth-century European painter to rank with him as an outstanding modern caricaturist.

All Daumier's lithographs have an inspired quality and it is easy to see in *The Freedom of the Press* (Plate 10) the prototype for the modern socialist poster, whether Russian, Cuban or Italian; or to recognize, as Baudelaire did, that the effect of the *Rue Transnonain* relies on its stark economy: the few sprawled figures and the single, overturned chair.

(opposite)

1 Gargantua

PARIS, Bibliothèque Nationale. 1831. Lithograph 30·5 x 21·4 cm. Signed bottom left: h.Daumier. (H. & D. 214). This lithograph, which was notorious in the 1830s, became legendary after Daumier's death. When Jules Michelet recorded in his diary for March 1850 that Rabelais had become an important source of inspiration for modern society, he might even have had this print in mind because it represents the most striking pictorial reference to *Gargantua* of the nineteenth century. Michelet was one of the artist's close friends who ardently admired the early political cartoons and collected them whenever he could. Gargantua was a work which made Daumier's satirical prints of the 1830s rare items for a private collection, because succeeding periods of censorship banished such savagery from the artist's repertoire. The scarce proofs of *Gargantua* are still sought and even today it is regarded as a supremely outrageous satirical attack on an individual. King Louis Philippe, transformed into Rabelais's Gargantua, is being fed by small figures dressed as Senators who carry backbaskets filled with écus and who climb up a ramp into the giant's mouth. At the top they disappear into the mouth itself. Below, these baskets are being filled by a group of ragged, starving people which includes a cripple, a printer and a dying woman trying to feed her baby. Gargantua excretes scraps of paper inscribed with the words 'Nominations de Paris' (nominations to the Chamber of Peers) and 'BREVET' (commission). These honours are caught by full-bellied toadies, similar to those who feed the giant, all of whom seem to have his face. Underneath Gargantua's throne-commode the Palais Bourbon is just visible and, to the right, the towers of Notre-Dame rise silhouetted above the crowd of distressed people. Daumier's knowledge of Rabelais's *Gargantua and Pantagruel* may have equalled his interest in another early literary masterpiece, Cervantes's *Don Quixote* (see Plates 87–92). These works became popular in the nineteenth century and the two writers were often linked together, notably by Victor Hugo who called them 'Homeric buffoons' who 'summed up horror by laughter'. At least two new editions of Rabelais appeared in France in the nineteenth century before 1830, and this lithograph contains specific references to both *Gargantua* and *Pantagruel*. The view of Notre-Dame suggests the episode in *Gargantua*, Book I, Chapter XVII, in which Gargantua steals the bells of Notre-Dame and the people of Paris beg him to return them; in Pantagruel, Book II, Chapter XXXII, the writer, Alcofribas, climbs into Pantagruel's mouth and finds a new kingdom. Pantagruel subsequently bestows the domain of Salgamundi on Alcofribas as a reward for his effrontery in defecating down the giant's throat. Daumier's updating of the satire makes French Senators bearing money climb into Louis Philippe's mouth, causing the king to excrete favours. Nineteenth-century historians interpreted this as an indictment of Louis Philippe's civil list which was the subject of debate between 1831 and 1832.

Louis Philippe, duc d'Orléans, acclaimed as 'King of the French' in July 1830, was called to the throne by Lafayette after the expulsion of Charles X, who had been ousted by the second revolution to take place in France in less than fifty years. Louis Philippe's eighteen-year reign was a difficult one and ended in 1848 when the king aroused the antagonism of his own supporters. Even in the first few months of the July monarchy, the king's critics were many, particularly among republican opponents. Freedom of the press was guaranteed as a condition of the king's accession, and this allowed political cartoonists unprecedented freedom to attack him. Published by the printers of *La Caricature*, Aubert & Delaporte, Daumier's *Gargantua* may have been intended for the paper although the artist was then still working for Philipon on a free-lance basis. Police removed the lithographic stone from the printer's premises in December 1831 and Philipon retaliated by publishing an ironic defence of *Gargantua* in *La Caricature*, 29 December 1831, which also, incidentally, gave the readers a detailed description of the plate they could not see: 'Gargantua does not resemble Louis Philippe: the top of his head is narrow, its base wide; he has the Bourbon nose and large features; but far from presenting that air of frankness, liberality and nobility which distinguishes Louis Philippe from all other living kings who, between ourselves, don't shine with such qualities, M. Gargantua has a repulsive face and a voracious air which makes the gold pieces tremble in his pocket.' Philipon himself was convicted three times for offences against the king. Altogether he spent more than a year in prison and his newspaper came under great financial pressure because of the resulting fines. Daumier, Delaporte and Aubert were tried on 23 February 1832, charged with the same offence, and each received a prison sentence of six months and fines of 500 francs. In March 1832 Philipon organized his Monthly Print Club (*L'Association Mensuelle*, Plates 9–11) run on a subscription basis to help pay the fines. All the cartoonists who worked for Philipon on *La Caricature* attacked Louis Philippe's distribution of honours, titles and sinecures and it is not known if Daumier or Philipon himself actually devised the content of *Gargantua*. Nevertheless it is this print, perhaps more than any other lithograph produced by the artist, which established Daumier's reputation as the most biting visual satirist of the nineteenth century.

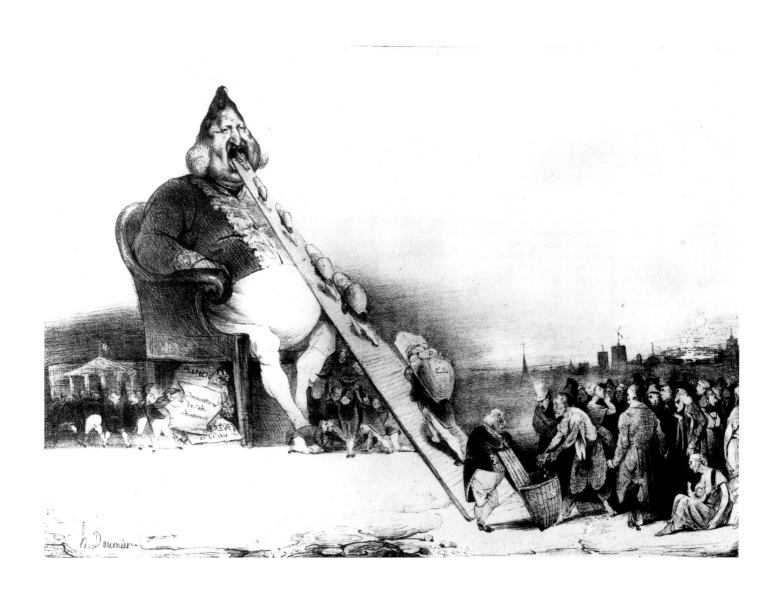

2 *Two Ragpickers*

LONDON, British Museum, Department of Prints and
Drawings. c.1830. Lithograph 21 x 18·2 cm. Signed bottom
left: h.Daumier. (H. & D. 199).

Inscription on a lithograph by Charlet hanging in the dealer's
stall on the right: Celui qui s'bat c'est pas celui qui mange la
galette from the proverb in La Fontaine's *Contes*: 'He who
does the fighting isn't he who steals the pickings'.

The caption reads: 'The kid's right. It's us what made the
revolution and them as gets the pickings.' ['Il a raison
l'moutard – eh oui c'est nous qu'à fait la révolution et c'est
eux qui la mangent . . . (la galette)']. 'Moutard' (kid) was a
slang word which appeared in the late 1820s and became
associated with the rebels of 1830.

One ragpicker wears a policeman's helmet, and both carry
backbaskets identical to those borne by the 'toadies' in
Gargantua (Plate 1). Nicolas Toussaint Charlet (1792–1845)
produced over 2000 commercial lithographs of street scenes
in which wry humour and tough characterization sharpened
the punchy effect of the wit. Daumier's two toughs speak a
variety of Parisian street slang, possibly written by the artist
himself, and they are almost brutal in appearance. Working-
class cynicism over the outcome of the 1830 revolution is
consequently made to seem harsher than that expressed by
the heroic attitudes of the workmen whom Daumier later
drew for Philipon (Plate 10). At this stage in his career the
artist had been working for *La Silhouette* producing designs
which show the influence of Charlet. This isolated print is
now extremely rare. Its sentiment, however, does return in
later lithographs (Plate 12) and the moral of the proverb was
made the subject of the painting *The Thieves and the Ass*
(Plate 20).

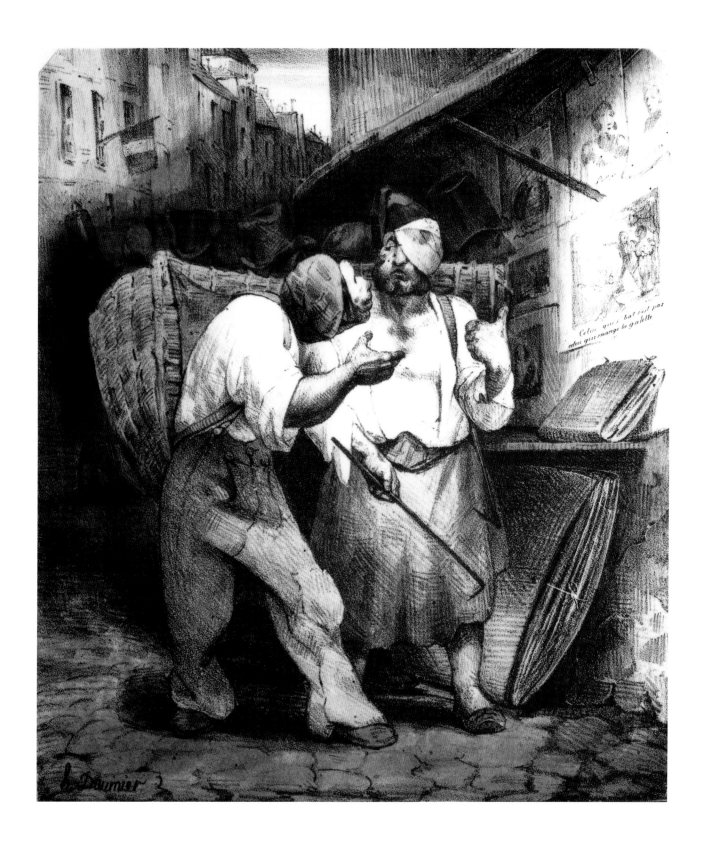

3 *Masks of 1831 (Masques de 1831)*

LONDON, British Museum, Department of Prints and
Drawings. *La Caricature*, 8 March 1832. Lithograph 21·2 x
29 cm. Signed bottom right: Rogelin. (H. & D. 250).
The identities of these masks correspond to those of the
portrait busts (Plates 5 and 7) and *The Legislative Belly* (Plate
9). The faceless pear-head (Louis Philippe, King of the
French), placed exactly in the centre, has fourteen possible
masks, all representing members of the Legislative
Assembly, from left to right: 'Eti', Charles Etienne
(1777–1845), a member of the Académie Française under
Napoleon I, and subsequently deputy of the Meuse for the
years 1822, 1827 and 1828, was eventually created a Peer of
France; 'Guiz', François-Pierre Guizot (1787–1874), was
often caricatured by Daumier (see Plate 9); 'Madier de M.',
Paulin Madier de Montjau (1775–1865), a lawyer and
politician; 'Thi', Adolphe Thiers (1797–1877), eventual
President of the Third Republic, and another favourite
target for professional lampooners, was probably caricatured
by Daumier more than any other politician of the
nineteenth century; 'Ath', Baron Louis-Marie Athalin
(1784–1856), Peer of France in 1840; 'Lam', Charles-
François, comte de Lameth (1757–1832), Conservative
member under Louis Philippe, first distinguished himself
during the *ancien régime*, emigrated in 1792 after taking an
active part in the 1789 revolution and was called back into
power by Napoleon, losing everything at the Restoration;
'Dup', André-Marie Dupin (1783–1865), a deputy under the
Restoration, prominent in the defence of freedom of the
press, was made President of the Chamber of Deputies by
Louis Philippe and campaigned for the suppression of
independent political associations; 'D'Arg', Antoine-Maurice
Apollinaire, comte d'Argout (1782–1858), was frequently
caricatured by Daumier (Plates 4–6); 'Kera', Comte Auguste
Hilarion de Kératry (1769–1859), a Liberal politician at the
Restoration who turned to the right under Louis Philippe
and later under Napoleon III, eventually becoming
President of the Council of State; 'D', unidentified; 'Bart',

Félix Barthe (1795–1863), lawyer and Warden of Sceaux in
1831, who presented a Bill in 1834 to repress independent
political associations and was a strong supporter of
censorship of the press; 'Seringot', Georges Mouton, comte
de Lobau (1770–1838), Napoleonic general and Marshal of
France who obtained his title in 1809 after the battle of
Essling and the defence of the island of Lobau, and
eventually commanded the army under Louis Philippe;
'Soul', Nicolas-Jean-de-Dieu Soult (1769–1851), also a
Napoleonic Marshal of France, was exiled by Louis XVIII,
supported Louis Philippe in 1830 and subsequently was
Minister of War in 1834 and 1840 and Foreign Minister in
1839, and whose art collection sold for 1,467,000 francs
after his death; 'Scho', Auguste-Jean-Marie, baron von
Schoenen, an obscure politician, who was born in 1782.

This was among the first of Daumier's lithographs to appear
in Philipon's paper *La Caricature* when the artist used his
early pseudonym 'Rogelin'; soon to be replaced by 'Honoré',
'h.Daumier' and the initials 'h.D.'. The design is Daumier's
modification of the stock convention of European
caricature, in which separate physiognomies are placed
together in order to exploit contrasting formal relationships.
Early nineteenth-century fascination with physical
characteristics as an expression of personality made a
publication such as Caspar Lavater's great work *Physiognomy*
immensely popular. The mock-seriousness of Boilly's *Receuil
des grimaces* (fig. 12) and the distortions of J.-P. Dantan's
caricature busts (fig. 11) reflect an equal delight in devising
satirical physiognomies. These, however, form only a few of
the sources from which Daumier may have drawn
inspiration. The exercise was the standard type of visual
lampoon which even Hogarth (fig. 2) would have
appreciated. But here the content has been drastically
updated, probably at the dictation of Philipon.

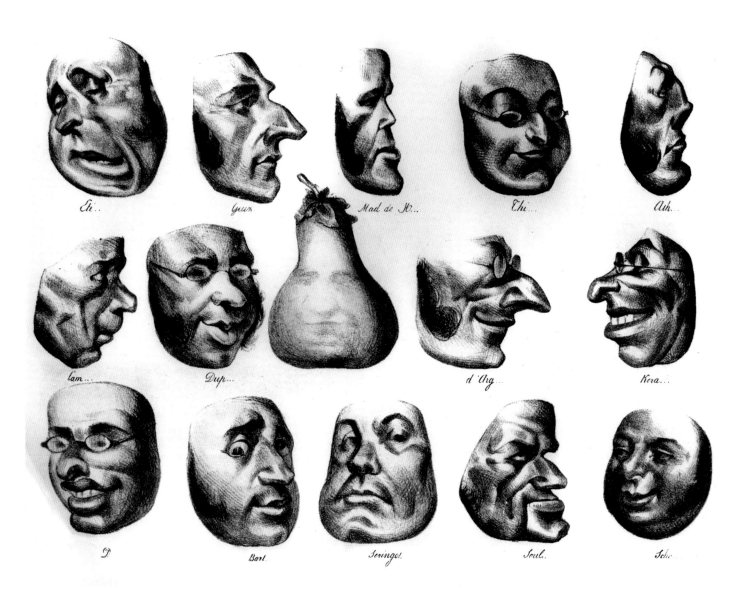

Eti... Guin... Mad de M... Thi... Ath...

Lam... Dup... d'Arg... Kera...

D Bart. Seringot. Soul. Sch...

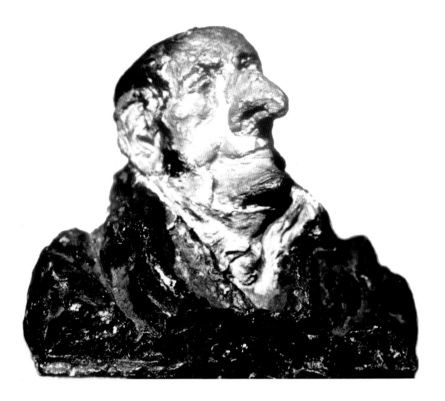

4 *D'Arg*

PARIS, private collection. c. 1832–33.
Unbaked painted clay 13·6 cm. high.
Antoine-Maurice Apollinaire, comte d'Argout
(1782–1858), the financier, became the Minister of
Commerce, Public Works and Fine Arts under Louis
Philippe. Daumier often caricatured him; he appears in
Masks of 1831 (Plate 3), *The Legislative Belly* (Plate 9) and
numerous plates in *La Caricature* and *Le Charivari*. During
the early 1830s Daumier made clay portrait busts for
Philipon of most of the politicians who appear in *Masks
of 1831*, with the notable exception of Thiers. Daumier
added many famous faces to this series including the
notorious Persil (Plate 10) and Clément Prunelle (Plate
7). Originally there may have been more than forty small
busts which, contrary to popular belief, Daumier did not
model in the Chamber of Peers itself. In an edition of
La Caricature which appeared in April 1832, Philipon
announced: '*La Caricature* formerly promised to give its
subscribers a portrait series of celebrities of the *juste-
milieu* . . . Being used to finding all possible means of
success for its publications *La Caricature* deferred the
realization of this project for some time so that it could
have each personage modelled *en maquette*.' It is not
known exactly when the artist started this, his first major
work in sculpture, but it may have been a project
suggested by Philipon and inspired by the figurines and
busts of J.-P. Dantan (fig. 11), which were popular in
Paris and London in the 1820s and 1830s. Encouraged
possibly by his close friend, the sculptor Préault (fig. 3),
Daumier modelled these busts in fine clay interspersed
with thicker particles, which prevented the heads
cracking or shrinking as they dried. This bust was
modelled in sections, the nose being produced separately
and then stuck on and coloured blue. The painting was
the final stage in the production, and it is unlikely that
the busts were intended for baking. Stylistically these
heads are three-dimensional extensions of the portrait
lithographs. Daumier even imitated the gleaming
contrasts of his lithographic drawing by digging deep
indentations into the clay. Eventually fifty portraits were
published in *La Caricature* and *Le Charivari*, many of
which follow these models almost exactly (Plate 6). First
shown to the public in the office windows of *La
Caricature's* printer, Aubert, the busts later appeared at
Daumier's exhibition of 1878 where possibly this head
and a few others were accompanied by photographs of
the remainder. Extremely fragile, they have been
extensively photographed in both the nineteenth and the
twentieth centuries, but were not cast in bronze until
1929, two years after the Philipon family sold the whole
collection.

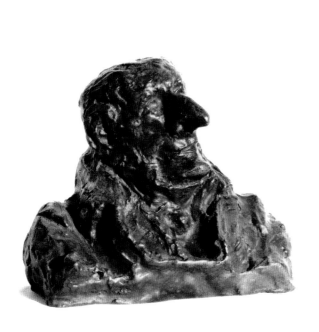

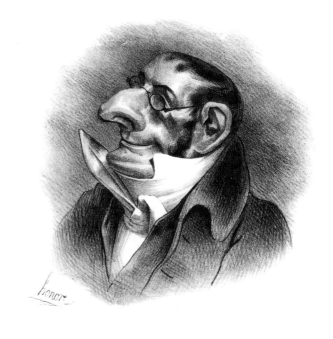

(above left)

5 *D'Arg*

MARSEILLES, Musée des Beaux-Arts. Bronze 13·6 cm. high. The Musée des Beaux-Arts, Marseilles, is one of the few collections to possess a complete set of the thirty-six busts in bronze. The first bronze edition, begun in 1929 and completed in 1948, was made by Maurice LeGarrec at the Barbedienne Foundry; the second edition at the Valsuani Foundry between 1953 and 1965. Altogether 1058 bronze casts were produced from the original clay busts, and the Marseilles versions, numbered '20', are probably first editions.

(above right)

6 *D'Arg*

LONDON, British Library. *La Caricature*, 9 August 1832. Lithograph 29·2 x 15·4 cm. Signed left: honoré. (H. & D. 4). Philipon's caption reads: 'The quintessential nose of M. d'Arg . . . has been the subject of so many articles, lampoons and caricatures that our subscribers must be quite familiar with it. But we thought that they might like to have an exact portrait without any exaggeration in the line of those we have already published of M. le Maréchal Sou . . ., Dup . . ., aîné, Ch. de Lam . . . (see Plate 3) and others. That is the key to our caricatures. We shall continue the gallery which will, in time, become rare and valuable.' The scissors refer to d'Argout's activities as a censor, and the escutcheon is inscribed: 'Everyone is entitled to massacre the language'.

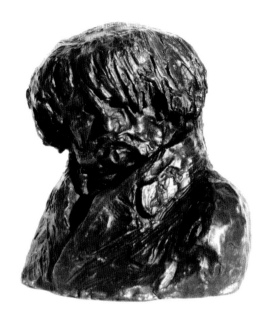

7 *Clément Prunelle*
MARSEILLES, Musée des Beaux-Arts. Bronze 13·5 cm. high.
Clément-François-Victor-Gabriel Prunelle (1774–1853),
doctor, Deputy and the Mayor of Lyon, was a liberal
politician nicknamed 'The Bison', presumably because of
the way he wore his hair. He appears in the foreground of
The Legislative Belly (Plate 9) and Daumier's full-length
portrait of him *M. Prune* was published in *La Caricature* on
27 June 1833.

(opposite)
8 *Souvenir of Sainte-Pélagie* (*Souvenir de Sainte-Pélagie*)
LONDON, British Museum, Department of Prints and
Drawings. 1834. Lithograph 24·7 x 18·8 cm. Signed bottom
left: h. Daumier. (H. & D. 225).
'I must have been born to attract nicknames for as soon as
I arrived here, as people remembered my character rather
than my name, they started calling me Gargantua.' This
extract is from one of Daumier's few surviving letters and
was written in the Sainte-Pélagie prison for political
offenders on 8 October 1832 to his friend, the painter
Jeanron. 'Prison will leave no painful memories,' continued
Daumier. 'Quite the contrary. If only I had a little more ink

for my inkwell is empty – it's very irritating to keep dipping
your pen in the whole time – with that exception I don't
think I lack for anything. I'm working four times harder in
this "boarding house" than I did at Papa's . . . I'm mortified,
grieved, vexed that there are things preventing you from
coming to see your friend La Gouape [the kid] alias
Gargantua.' Daumier entered Sainte-Pélagie on 31 August
1832 and left on 11 November. As his letter suggests, his
imprisonment was fairly lenient. He was also able to work
despite a lack of lithographic stones, and he sent his
drawings out to Ramelet, a fellow engraver, for printing.
Philipon wrote to Daumier's father on the day the artist
went to prison, promising to use his influence to obtain
Daumier's transfer to the prison hospital as soon as
possible. On 11 November Daumier was taken to the home
of Dr Casimir Pinel who ran a sanatorium for political
prisoners and mental patients. There Daumier remained in
relative comfort until his official release on 22 February
1833. In Sainte-Pélagie the artist occupied cell number 102
which, according to a report published by the *Gazette de
Sainte-Pélagie* on 17 January 1833, was decorated with a large
drawing of *Gargantua* (Plate 1), the print which led to the
artist's arrest. It is possible that Daumier here represented
his own cell and it has even been suggested that the figure
standing on the left is the artist himself. Champfleury
tentatively identified all three figures as the engraver
Larouge, the lawyer London and the writer Massé (or
Masson) but these identifications cannot be substantiated.
In the letter quoted above, Daumier added that he was
making a lot of portraits, which suggests that the highly
finished figures in this picture come from drawings made
inside the prison. On 14 March an earlier version of *Souvenir
of Sainte-Pélagie*, printed in reverse, appeared in *Le Charivari*;
the version here is a later reworking by Daumier, probably
made at a time when the printing of *La Tribune* had been
suspended (see Plate 11). A rare lithograph, this work is
probably one of Daumier's best prints, but no trial proof
for it has ever been found. The texturing of the figures and
the animated deep shadows give the scene a richness and
monumentality equal to the *Rue Transnonain* (Plate 11) and
the figure on the left resembles the heroic printer who
dominates the print *Freedom of the Press* (Plate 10) from
L'Association Mensuelle.

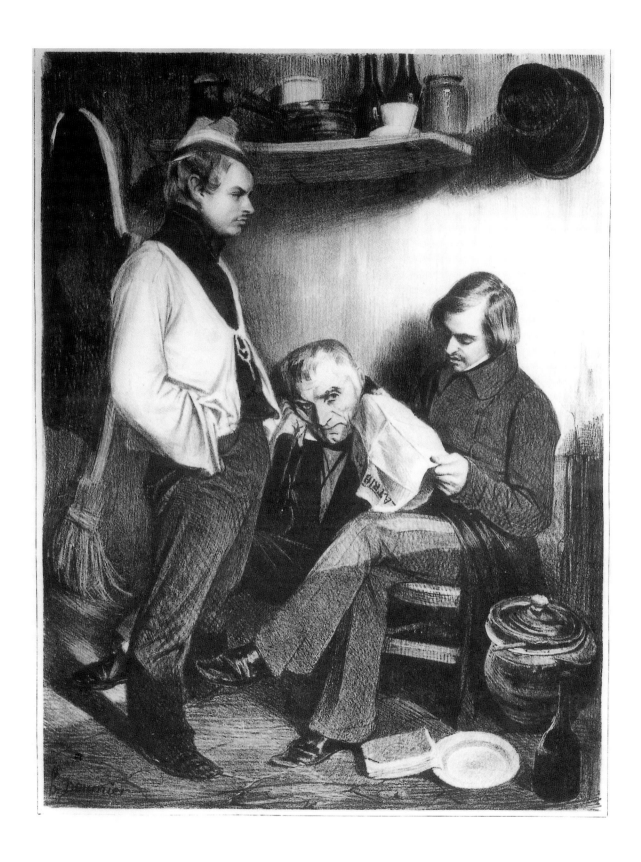

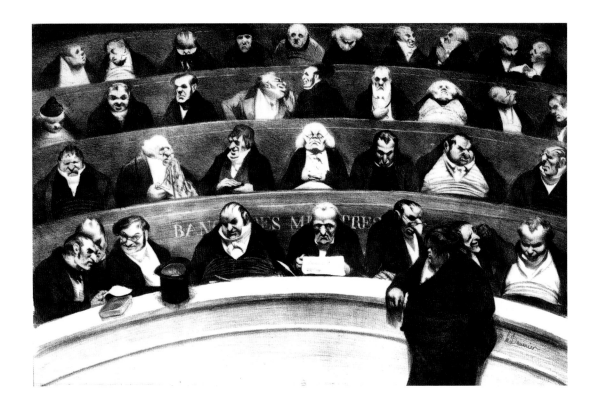

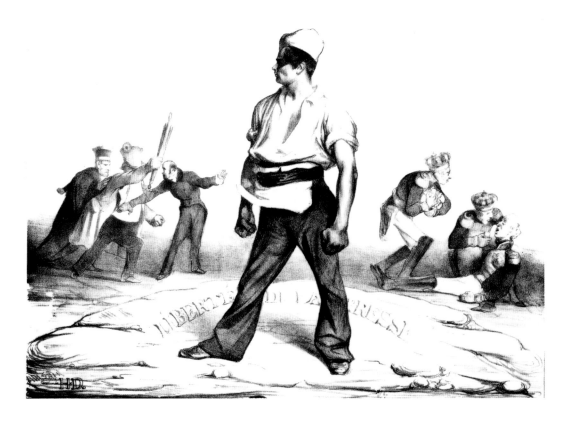

9 *The Legislative Belly* (*Le ventre législatif*)
PARIS, Bibliothèque Nationale. *L'Association Mensuelle*,
number eighteen, 13 January 1834. Lithograph 28 x 43·1 cm.
Signed bottom right: h.Daumier. (H. & D. 306).
The first design Daumier made for Philipon's monthly print
club, this lithograph follows the themes of two earlier
political caricatures, *Gargantua* (Plate 1) and *Masks of 1831*
(Plate 3). The faces of the 'masks' reappear as members of
the Legislative Assembly, and Daumier added many more
Deputies who also form the gallery of portrait busts and
caricatures (Plates 4–7). Some of their identities are familiar:
Prunelle (Plate 7) stands in the foreground, and the front
row is dominated by Guizot, Thiers, Barthe, Soult and
d'Argout. Second from the left sits Jean-Charles Persil
(1785–1870), a magistrate and a politician, and one of
Philipon's particular adversaries, whose thin skull and
prominent chin Daumier viciously lengthened in his clay
head (Paris, private collection). Persil, having just been
created Minister of Justice, received the police file on the
massacre in the rue Transnonain (Plate 11). He was strongly
in favour of press censorship and he also appears in the
background of Daumier's third print in this series, *The
Freedom of the Press* (Plate 10). In *The Legislative Belly* the
characters who sit behind those in the front row are less easy
to identify. Etienne (Plate 3) is thought to be at the top on
the extreme right and Kératry (Plate 3) in the third row,
fourth from the right. Philipon's accompanying caption
substituted 'Le ventre législatif' ['Legislative Belly' or 'Bag of
Wind'] for 'Le corps législatif' ['Legislative Body' or
'Legislative Assembly']. 'The *belly* is the container of all the
intestines into which the digested budget precipitates . . . the
belly is the Minister's god, it is the soul of the legislative body
. . . the *belly* and the *buttocks* which have toiled for the last
four years for the happiness of France . . . To them we owe
. . . the abandonment of all the people who had staked
everything on the 1830 revolution (see Plates 2 and 12). To
them we owe the budget increase and the resulting tax
increase . . . Here is the legislative belly . . .' The curved row
of seats in the Chamber illustrates this commentary just as
Philipon's visceral imagery, which metamorphosizes
legislative procedures into digestive processes, looks back to
the theme of *Gargantua* (Plate 1).

10 *The Freedom of the Press*
LONDON, British Museum, Department of Prints and
Drawings. *L'Association Mensuelle*, number twenty, 20 March
1834. Lithograph 42 x 29·1 cm. Initialled bottom left:
H.D. (H. & D. 919). Caption: 'Watch it!!' ['Ne vous y
Frottez Pas!!']
This is Daumier's third plate for *L'Association Mensuelle* and
shows a boxing match. On the right Charles X lies prostrate,
having been knocked out by a muscular printer: a reference
to the rôle of the press during the 1830 revolution. The new
challenger on the left waving his umbrella is Louis Philippe,
restrained by Odilon Barrot but encouraged by Persil (Plate
9). The figure of the printer is not unlike that of the
prisoner in the foreground in *Souvenir of Sainte-Pélagie* (Plate
8). Daumier had already designed cartoons on the same
theme for *La Caricature*. One, published on 3 October 1833,
bears almost the same caption: 'Ah! tu veux [te] frotter à la
presse!!' and shows another heroic printer crushing the top-
hatted figure of Louis Philippe inside a printing press. The
king's symbol of power, the umbrella, lies in the foreground.
Daumier often put printers into the political lithographs of
the early 1830s (see Plate 1), a practice which ceased after
the censorship law was passed in 1835 (see Plate 12).

(opposite)

11 *Rue Transnonain*

LONDON, British Museum, Department of Prints and Drawings. *L'Association Mensuelle*, number twenty-four, July–August 1834. Lithograph 44·5 x 29 cm. Initialled bottom left: H.D. (H. & D. 310).

In April 1834 demonstrators erected barricades across the narrowest streets of Paris as a protest against a law, just passed by the Legislative Assembly (Plate 9), prohibiting privately-sponsored, small political associations. Already this new 'Law of Associations' had caused an uprising among silk workers in Lyon, and Louis Philippe was obliged to call in the army to help control the Paris riots and remove the barricades. On the evening of Sunday 13 April 1834, a number of tenants living in a house on the corner of rue Transnonain and rue Montmorency found themselves besieged by violent demonstrators who demanded aid in building a high barricade across the street. Terrified, the tenants bolted their front door, refusing to let anyone in until 5 o'clock the following morning when a detachment of light infantry arrived, tore down the barricade and scattered the demonstrators. What happened when the tenants opened their door to the victorious soldiers is the subject of Daumier's lithograph and of numerous nineteenth-century accounts. It was several days before the story reached most of the newspapers, although *Le National* apparently got hold of it by the evening of 14 April. *Le Charivari* reported only that there had been trouble in the Quartier Saint-Martin, but on 15 April it managed to fill in some of the details by describing how a captain of light infantry had been wounded at a barricade and his soldiers had subsequently killed some thirty people, the youngest of whom was sixteen. By 16 April *Le Messager* described the operation as a military triumph, while *Le Charivari* denounced it as a massacre in which the soldiers had not regarded the age or sex of their victims. On 17 April *Le National* printed another story: infantrymen of the 35th Regiment had entered a house in the rue Transnonain and killed a number of people, including a six-year-old child. By 18 April, however, the newspapers had turned their attention to the imminent threat of press censorship. The events in the rue Transnonain were overshadowed by a police raid which had taken place on the offices of the violently republican newspaper *La Tribune Politique et Littéraire* on 13 April. Reporters and printers were arrested and the paper did not appear again until 11 August. As interest in the rue Transnonain atrocity waned, it was left to the lawyer Ledru-Rollin, leader of the Radicals, to attempt a detailed investigation and he held a public enquiry. Ledru-Rollin published the testimony of numerous witnesses, including surviving tenants of the house and infantrymen who had taken part in the raid. Many of these witnesses, especially the soldiers, could not remember the events very clearly but they did establish that a captain of light infantry was shot by a sniper at the barricade, and that consequently his detachment had orders to enter the nearest house and kill every male inhabitant over a certain age. This had already happened earlier in the rue Maubuée, where soldiers were publicly commended for their courage in entering two houses and killing ninety-six insurgents. Some witnesses confirmed the soldiers' story, while also affirming that the sniper's bullet could not possibly have come from the house in the rue Transnonain. Nevertheless, when the detachment entered the house on the morning of 14 April they killed all the men inside, including an elderly man in his nightclothes. Most of the victims were shot at point-blank range and powder burns were found on their clothes. Several were bayoneted. No women died and, at one point, the soldiers apparently apologized to the victims' wives for having to carry out such terrible orders. A few women were hurt in the struggle and a small child severely injured when his father, who was holding him, was shot dead. Ledru-Rollin observed in his conclusion that Article 359 of the Constitution prohibited police entry into private property at night, and only during the day with a court order, but his enquiry was partisan, designed principally to attack Thiers (Plate 3), the Minister of the Interior. The results of his investigation appeared in pamphlet form in July 1834. On sale to the public at seventy-five centimes per copy, it was instantly sold out and went into three editions before the end of the year.

Daumier's lithograph probably appeared just after, either at the end of July or the beginning of August 1834, and it forms the last print in Philipon's *L'Association Mensuelle* series. Philipon accompanied Daumier's lithograph with a description of the subject as well as an explanation of why *L'Association Mensuelle* was going out of business: the government had introduced a stamp tax on all such prints which would not only take the profits but also spoil the designs, as the rubber stamp would be placed across the face of each one. The complete set of twenty-four plates from *L'Association Mensuelle* was offered for sale at a price of twenty-four francs per set and Daumier's *Rue Transnonain* forms a fitting climax to the series. Both artist and editor

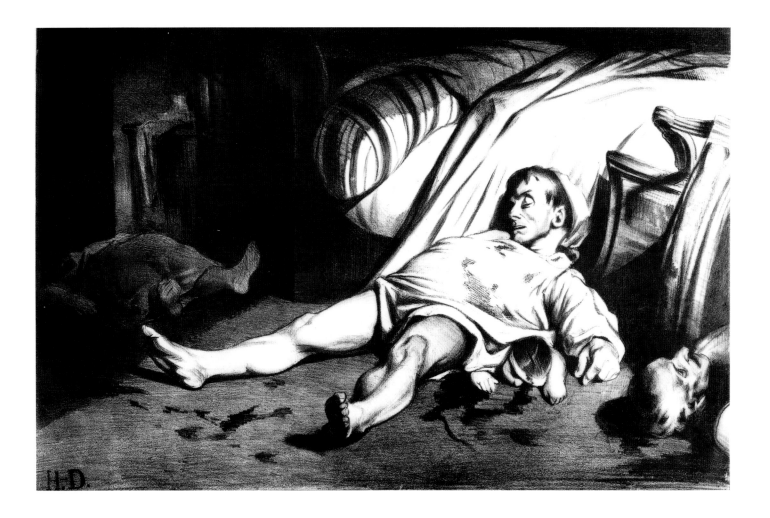

may have read Ledru-Rollin's pamphlet, and the scene is set by Daumier in a bedroom, a scene described graphically by one of the witnesses. However, there are also a number of inaccuracies, possibly inserted for artistic as well as political reasons. The dead woman and child were not actual victims but are obviously more effective images than the authentic dozen or so male corpses. The economy of this design is also important. Daumier constructed the work with the simplicity of a sculptured frieze, perhaps inspired by a relief which his friend Préault exhibited at the Salon of 1834, only a month or two earlier. Entitled *The Massacre* (fig. 3), Préault's relief shows a child, a middle-aged man and an elderly man, a negro and a woman all dramatically foreshortened.

However, the crushed child and overturned chair in *Rue Transnonain* are precise transcriptions of details from a plate in Goya's famous series of etchings *The Disasters of War* (fig. 15). Daumier is known to have admired Goya, and he used these two details again in his caricatures of the 1840s (Plates 51 and 52). Throughout the nineteenth and twentieth centuries this lithograph has remained one of Daumier's most famous works, although proofs of it are now as rare as those of *Gargantua* (Plate 1). Here is seen the climax of all Daumier's skills as a graphic designer, and Baudelaire made *Rue Transnonain* the centrepiece of his article of 1857, 'Some French Caricaturists': '. . . it is history, it is reality, trivial and terrible . . . In this cold attic nothing but silence and death.'

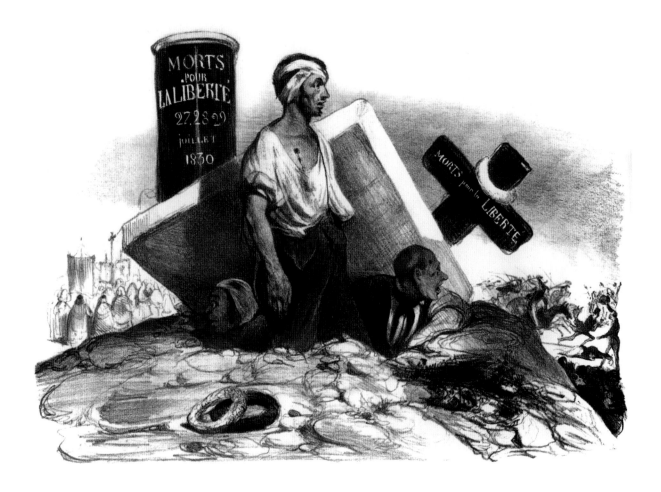

12 *Wasn't Much Point in Getting Us Killed, Was There! (C'était vraiment bien la peine de nous faire tuer!)*
LONDON, British Museum, Department of Prints and Drawings. *La Caricature*, 27 August 1835.
Lithograph 29 x 21 cm. Unsigned. (H. & D. 305).
Inscription on the monument: MORTS pour LA LIBERTÉ 27, 28, 29 Juillet 1830 [Died for Liberty on the 27, 28 and 29 July 1830]; on the cross: MORTS pour la LIBERTÉ.

Three dead men, martyrs of the 1830 revolution, emerge from their tombs to watch a distant scene of street fighting. With its elliptically-shaped foreground and steep drop in perspective back to the far view of soldiers breaking up a civilian demonstration, this design is an ironic reflection of Delacroix's *Liberty Leading the People*, which was bought by the state in 1830 (Paris, Musée du Louvre). Daumier admired Delacroix's work and the two artists seem often to have evolved similar compositions (see Plates 15 and 20). Delacroix's *Liberty Leading the People* was a pictorial

glorification of the 1830 uprisings in Paris. Daumier's print, on the other hand, changes the glory into despair. The female personification of Liberty, placed by Delacroix in the centre of his painting, is here replaced by the resurrected heroes and their bitter comment. Daumier also recalls his own earlier lithographs in this print: in *La Caricature*, 11 September 1834, the figure with bandaged head and scrubby beard also appears in a cartoon: he lies dead in prison where Louis Philippe in person pronounces him to be now fit for release; in a lithograph from *L'Association Mensuelle* of about the same time, *Rue Transnonain* (Plate 11), military repression of street demonstrations is shown to cause the death of innocent people. Such references make this work into a climax of Daumier's early political cartoons. August 1835 was the month when a bill to suppress the liberty of the press was the subject of a debate in the Chamber of Peers. Two days after this lithograph appeared, the bill was made law by a small majority and *La Caricature* closed down.

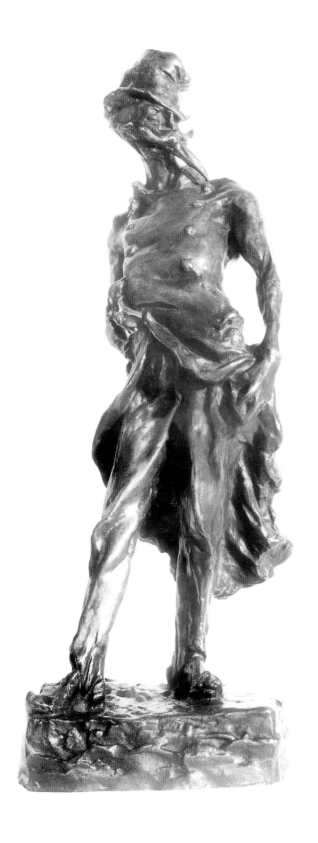

13 Ratapoil

MARSEILLES, Musée des Beaux-Arts. c. early 1850s.
Bronze 46 cm. high.

Apparently admired by Rodin in 1914, this figure also became familiar in Daumier's lithographs from about October 1850 onwards: the shabby Bonapartist wearing a battered hat, crumpled military coat and jaunty whiskers, whose toes poke out of his boots. He appears in all kinds of stock situations in *Le Charivari* cartoons, but the model probably antedates the lithographs. Daumier's fellow-sculptor, Geoffroy-Dechaume, made the first plaster cast of Ratapoil and designated him, 'the resumé of an epoch, the agitator who prepared the *coup d'état*'. According to some sources, after Napoleon III had seized power in 1851, Daumier was forced to conceal this figure for political reasons, although this seems unlikely. Nevertheless Daumier obviously treasured this little figure and worked on it for a long period. Originally modelled in clay, *Ratapoil* may have remained in Daumier's studio for several years; recent technical examinations carried out by Arthur Beale, Assistant Curator of the Fogg Museum, have revealed traces of rag impressions on the base, indicating that Daumier wrapped the figure in wet linen to keep the clay malleable. Modelled over an armature, *Ratapoil* remained unbaked since the thin projecting details such as his moustache and cane would not have survived the process. The figure was not exhibited at Daumier's exhibition in 1878, but was probably one of the first of Daumier's models to be cast in bronze at the Siot-Decauville Foundry in the 1890s. There are three main bronze editions, two cast in the 20th century, as well as three known plaster casts. One of these, made in 1960, is in an Italian private collection, while the original by Geoffroy-Dechaume is now in the Albright-Knox Gallery, Buffalo. The Marseilles bronze, shown here, is probably one of the first editions from the 1890s. Charles-Louis-Napoleon Bonaparte, nephew of Napoleon I and son of Louis Bonaparte, King of Holland, was elected President of the Second French Republic on 10 December 1848. Almost exactly three years later, on 2 December 1851, he ordered the arrest of leaders of the Republican and Royalist parties in France, dissolved the National Assembly, suppressed by force any public protest and, in 1852, declared himself Napoleon III, 'Emperor of the French'.

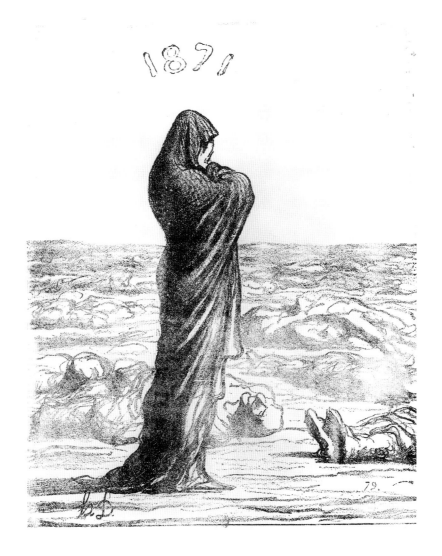

14 *Hideous Heritage* or *Appalled by the Legacy*
(*Epouvantée de l'héritage*)

PARIS, Bibliothèque Nationale. *Le Charivari*, 11 January 1871.
Lithograph 23 x 18 cm. Initialled bottom left: h.D.
(H. and D. 3447).

On 15 July 1870 France declared war on Prussia. The
French were confident of an easy victory, despite being
almost universally condemned as unjustified aggressors. Ill-
organized and ill-prepared, the French army was crushingly
defeated and Louis Napoleon surrendered to Bismarck at
Sedan on 30 August. After a short period of Prussian
captivity, the French emperor died in exile in Chislehurst,
Kent, two and a half years later. Paris, however, refused to
surrender and decided to resist the advancing Prussian
troops. The first siege of Paris lasted until the end of
January 1871 when starvation combined with the Prussian

bombardment forced the city to capitulate. Already two
attempted *coups d'état* had taken place inside Paris during the
siege, and after the harsh terms of the Prussian peace treaty
were made known, and an election in which Thiers (Plates 3
and 9) came to power, the government of Paris was seized
by the self-styled 'Commune' and the siege began again.
Daumier's lithograph was made just before the end of the
first siege and the elongation of the principal figure shows
that, by this time, the artist was nearly blind. This print was
later republished in an album entitled *The Album of the Siege*.
Daumier's war lithographs appeared between 7 September
1870 and 29 December 1871, except for the short period
when the Commune apparently closed down *Le Charivari*.
Daumier remained in Paris during this time and served on a
commission of artists appointed to look after works of art
and museums.

CLASSICAL AND RELIGIOUS WORKS

Daumier seems to have abandoned his ambition of becoming accepted as a history painter when he was actually just on the verge of success. In the light of his interest in the Académie and the official Salon before 1848, this renunciation of an academic career is inexplicable. In 1847 Daumier attempted to organize an independent salon exhibition, and in February 1848 he was one of many avant-garde artists to protest against the rules of the Académie. He evidently wanted to show his paintings in public at a salon exhibition, but after the 1848 revolution, when the Salon opened its doors to all artists and the provisional government sponsored a competition for painters with no bar on entry, Daumier did not exhibit and apparently had to be persuaded to participate in the competition. Having gained his first public success with the sketch *The Republic* (Plate 15), Daumier's subsequent behaviour is even more unaccountable. He must have studied the most popular subjects from previous Salons because his own Salon exhibits, submitted during 1849–51, represented traditionally successful subject matter which had often appeared in nineteenth-century Salons: a fable from La Fontaine (Plate 18); bacchanalian scenes (Plate 16) and the ever-popular *Don Quixote* (Plates 87–92). Yet, after *The Republic* won him his first government commission, Daumier not only failed to fulfil it, but repeatedly failed to meet even the modified terms of the commission (Plate 16), despite having received a fairly generous fee in advance.

In 1851 Daumier apparently decided to stop sending paintings to the Salon, although he did exhibit again ten years later, after temporarily leaving *Le Charivari*. Two valuable facts emerge from studying Daumier's 'official' pictures: the first is the range of source material, from Rubens to David, which Daumier skilfully incorporated into his work; the second in his enormous powers of visual representation which could encompass many different subjects. For instance, the muddle over his one state commission may have caused him to paint a religious work of the quality of *We want Barabbas!* (Plate 19) and a masterpiece in the style of Rubens (Plate 16). And if Daumier seems a more academic artist than is generally realized, then his independence was

probably quite calculated. Every pictorial experiment he undertook was founded on the classical fluidity of his draughtsmanship. Translated into paint, as it was in the 1840s, this graphic excellence gave new energy to orthodox subject matter, and Daumier continued to recreate his painted subjects and to achieve uniquely expressive variety in his drawings. While his lack of training as a painter may have given him many difficulties, it was perhaps as an amateur of genius that Daumier offered so many new ideas to fellow artists of the nineteenth century.

(opposite)

15 *Sketch for 'The Republic': The Republic Feeding her Children and Instructing them* (*La République nourrit ses enfants et les instruit*)
PARIS, Musée du Louvre. 1848.
Oil on canvas 73 x 60 cm. Unsigned.
In February 1848 Louis Philippe was driven from the French throne and the Second Republic was established. On 18 March the provisionary government organized a competition for a painted figure of 'The Republic'. Persuaded to compete by Courbet and Bonvin, Daumier submitted this sketch. Between 500 and 900 other sketches appeared from artists throughout France, although the complete number of entries for this remarkable competition has never been calculated. One of the most famous entries was that of Jean-François Millet (Oran, Musée National des Beaux-Arts). The subject remained popular for at least two years afterwards and the Salon of 1849 was dominated by figures of the Republic, Freedom and Liberty as well as representations of important events in the 1848 revolution. Daumier himself never returned to the subject, although his sketch was one of the twenty best works chosen by the jury in 1848. A payment of 500 francs commissioned Daumier to complete the sketch by May 1849. The artist did not manage to fulfil the commission, and promised instead to produce a religious work by September 1849 (see Plate 19). The model for this composition of *The Republic* has been traced, perhaps unexpectedly, to some pencil sketches from the studio of the classical painter J.-L. David (Detroit, Detroit Institute of Arts) which portray *La Patrie*. Daumier's design is therefore a traditional work, also resembling classical paintings of Charity, but the flat sections of the figure's body, the loose brushwork, long, flowing hair, muscular arms and brownish colouring suggest that Daumier had found another source of inspiration: Delacroix's massive female figures such as the allegorical 'Liberty' in the 1830 *Liberty Leading the People* (Paris, Musée du Louvre) and the great *Medea* which was exhibited at the Salon of 1838. A sheet of drawings by Daumier (Paris, Roger-Marx collection), showing a woman and child, is possibly the preliminary idea for *The Republic*, which also resembles a painting by Delacroix, the early *Virgin of the Harvest* (Orcement, parish church). This is the only allegorical painting from this period which the artist chose to send to his 1878 exhibition.

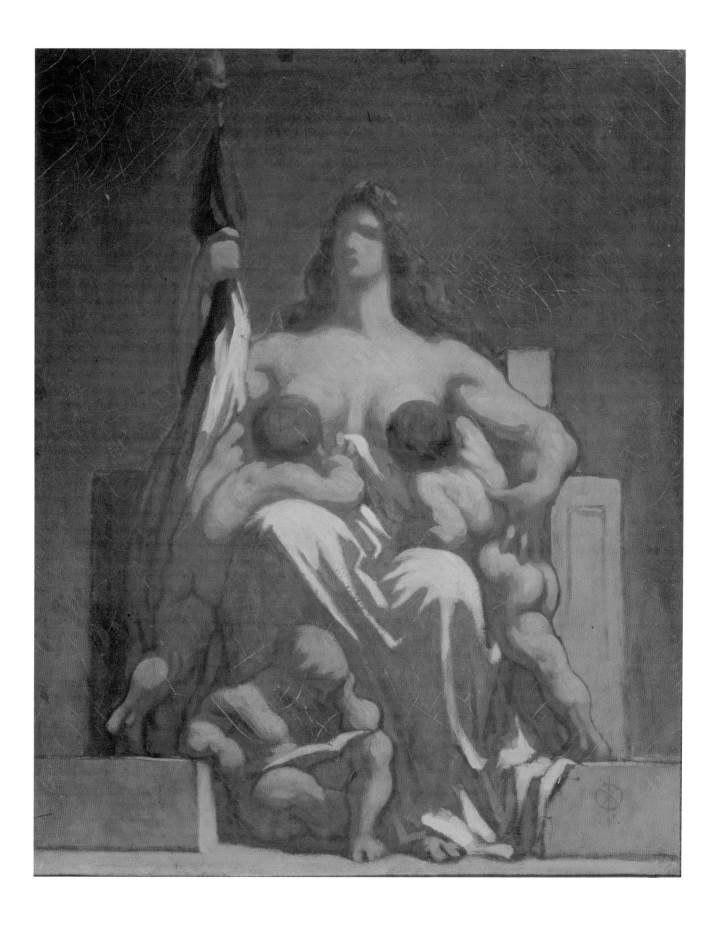

47

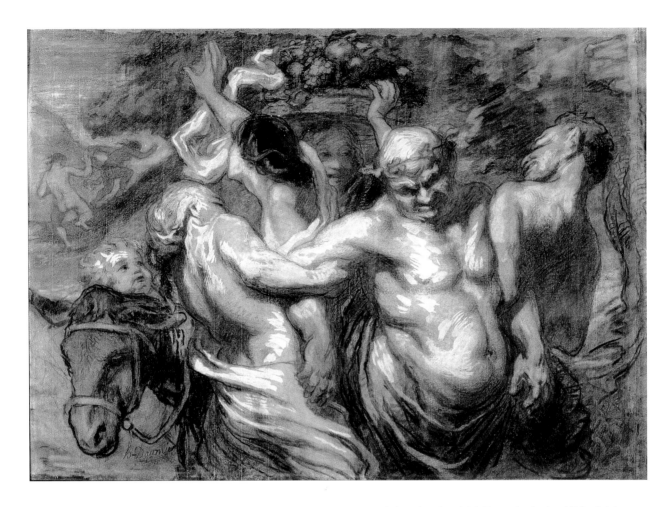

16 *The Drunkenness of Silenus* (*L'ivresse de Silène*)
CALAIS, Musée des Beaux-Arts. c. 1850. Crayon, charcoal
and stump heightened with white gouache on board 43 x
61 cm. Signed bottom left under donkey's rein: h.Daumier.
Having failed to finish *The Republic* (Plate 15) Daumier's
commission was changed and he was requested to paint the
Magdalene in the Desert for a provincial French church
(Switzerland, private collection). A proposal to pay 1000
francs in September 1848 was increased to 1500 francs in
February 1849, perhaps to encourage Daumier to start
painting. By this time his difficulties in finishing work had
become notorious in Paris, and Delacroix even noted this
fact in his *Journal* for 1849, at a time when he, too, was
finding it hard to complete his paintings. Nevertheless,
Daumier's *Magdalene* was not delivered and the subject was
refused by the Commission of the Académie des Beaux-
Arts. Four years later, in 1853, Daumier had still not
produced anything for the State. In 1863 the State finally

accepted this sketch, which Daumier had exhibited thirteen
years earlier at the Salon of 1850/51 and which had been
reproduced as a woodcut engraving in 1860 in *Le Temps
Illustrateur Universel*, where it was highly praised by the
brothers Goncourt. Now at Calais, the sketch is not one of
Daumier's popular works, perhaps because it depends so
obviously on a painting by Rubens, *The Triumph of Silenus*
(London, National Gallery) which Daumier probably copied
from a reverse engraving by N. de Lanney. Two of the
women in the foreground and the basket carried by the
central girl had already appeared in Daumier's painting *The
Miller, his Son and their Ass* (Plate 18) and there is a
preliminary study of Silenus in Stamford, Connecticut
(Goldschmidt collection). The rich textures and flowing
movements of this work actually make it a brilliant graphic
exercise, and demonstrate that the artist had not only
absorbed the style of Rubens but had also developed an
interest in the contours of figures on classical bas-reliefs.

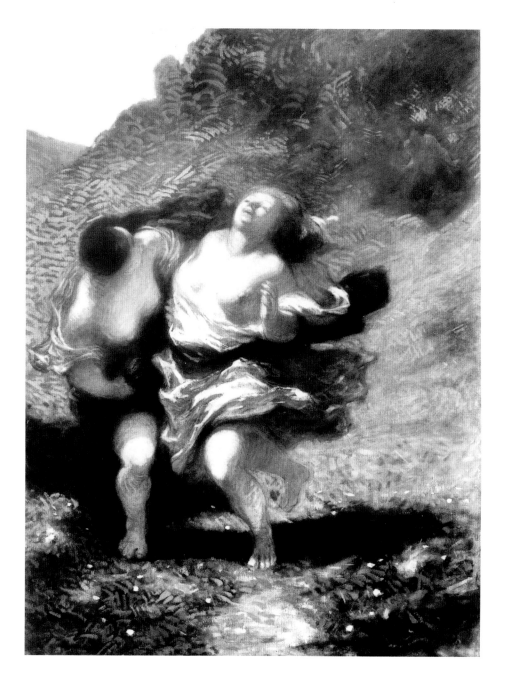

17 *Two Nymphs Pursued by Satyrs*
(*Deux nymphes poursuiviées par des satyres*)
MONTREAL, Museum of Fine Arts (Adaline Van Horne
bequest). 1850. Oil on canvas 128·5 x 96 cm. Initialled
bottom right: h.D.
Exhibited in Paris with *The Drunkenness of Silenus* (Plate 16)
and *Don Quixote* at the Salon of 1850/51, when it was called
Femmes poursuiviées par des satyres, this painting was violently
reworked by the artist after the exhibition and probably
ruined. In 1886 Daumier's biographer, Arsène Alexandre,
saw it when it was still in the possession of the artist's

widow and described the picture as 'striped and speckled
with wild brushstrokes'. Apparently dissatisfied with the
work, Daumier spoilt his original colouring by covering the
picture's surface with some new preparation. Daumier's
reaction may have been provoked by the adverse critical
reception of the work at the exhibition. One critic,
Chennevière, was especially severe, comparing both colour
and figures to a music hall burlesque, and maintaining that
the drawing was 'inferior to his [Daumier's] least successful
lithographs'. In 1961 the picture was restored to its
former state.

(above)

18 *The Miller, his Son and their Ass* (*Le meunier, son fils et l'âne*)
GLASGOW, City Art Gallery and Museum (Burrell
collection). 1849. Oil on canvas 130 x 97 cm. Signed bottom
right: h.Daumier.

This picture represents a popular subject from La Fontaine's
Contes from Book III, Chapter I which points the moral that
it is impossible to please everybody all the time. Numerous
nineteenth-century French artists used La Fontaine as an
exhibition subject and even Daumier was to paint another
La Fontaine parable, *The Thieves and the Ass* (Plate 20), a later
work which is sometimes confused with this one. This large
canvas was the only painting which Daumier sent to the
Salon of 1849 and it was never exhibited again in his own
lifetime. The three girls in the foreground resemble the
Rubensian figures in *The Drunkenness of Silenus* (Plate 16) and
the *Two Nymphs Pursued by Satyrs* (Plate 17), both of which
were exhibited the following year. Although the source for
all these females is Rubens, they also resemble some of the
heavy, bacchanalian women that Millet painted in the 1840s.
There are two preparatory oil sketches for this work: one
(Zürich, Nathan collection) shows the whole composition;
the second (Merion, Pennsylvania, Barnes Foundation) only
the three girls.

(opposite)

19 *We Want Barabbas!* (*Nous voulons Barabbas!*) or *Jesus and
Barabbas* (*Jésus et Barabbas*) or *Ecce Homo*
ESSEN, Museum Folkwang. c. 1850. Oil on canvas 162·3 x
130 cm. Unsigned.

Daumier's largest work, this painting is one of several
depicting scenes from the life of Christ which the artist
probably made between 1848 and c. 1850, when trying to
complete a state commission for a religious work (Plate 16).
An unfinished sketch, the picture has a technique similar to
that of *The Republic Feeding her Children and Instructing them*
(Plate 15). The bodies of the figures are painted in widely-
spaced blocks which create muscular distortions of the
limbs and torsos; the gestures are emphatic and although the
details are crudely painted, Daumier gave the scene
enormous tension and monumentality. The mask-like faces
in the foreground seem to anticipate many later
developments in early twentieth-century religious painting,
specifically works by Emil Nolde. Here Daumier's own
source of inspiration could have come from Rembrandt, but
he transformed the traditional imagery into one of the most
dramatic and individual religious works of the nineteenth
century. *We Want Barabbas!* invites comparisons with painters
as diverse as Delacroix, van Gogh, Ensor, Gauguin and
Munch.

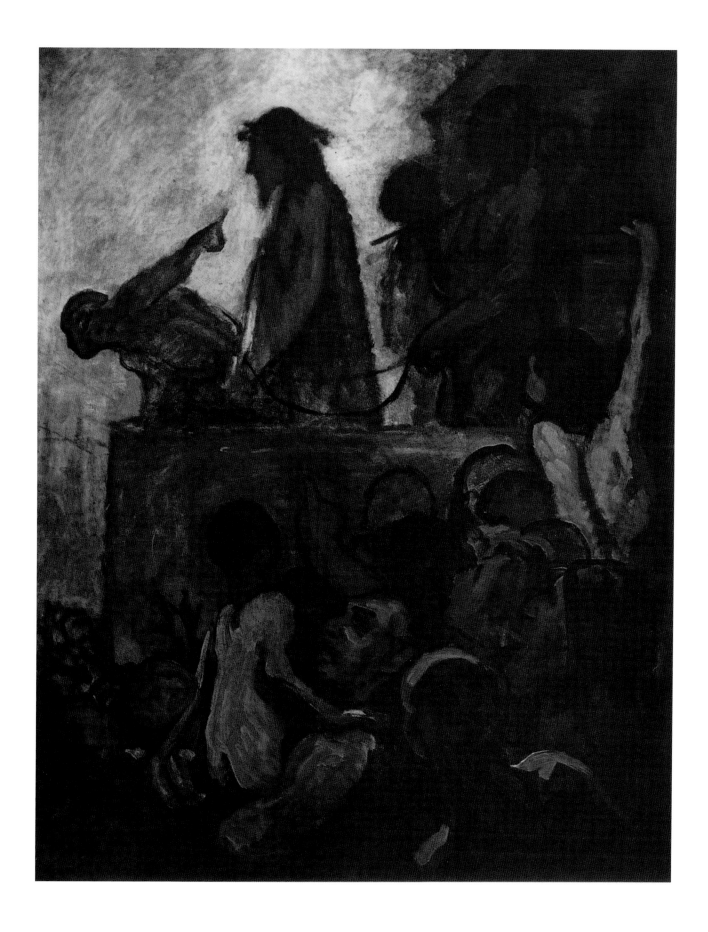

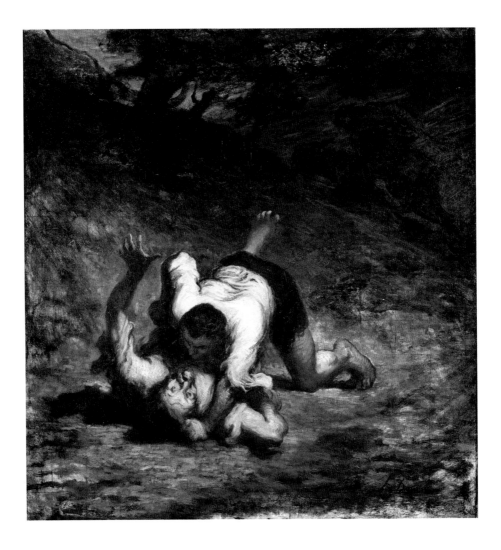

20 *The Thieves and the Ass* (*Les voleurs et l'âne*)
PARIS, Musée du Louvre. c. 1858 or after 1861. Oil on
canvas 59 x 56 cm. Signed bottom right: h.Daumier.
The subject is from La Fontaine, Book I, Chapter XIII: two
thieves fight for possession of a stolen ass while a third
makes off with the beast, unnoticed. Two preparatory chalk
drawings and an oil study for this painting all have the same
basic composition, in which the action is split between the
thieves and the rider with the aid of trees and a hill,
although one drawing (Paris, Roger-Marx collection)
eliminates the rider completely. This composition may have
been learned by Daumier from Delacroix's famous mural in
Saint-Sulpice in Paris, *The Fight between Jacob and the Angel*.
The mural was not completed and shown publicly until
1861, which would make the dating of Daumier's painting
later than is usually ascribed. However, Daumier could have
visited the older artist and seen his preparations, because
Delacroix's preliminary oil sketch (fig. 8) seems a more likely
source for Daumier's picture than the completed work. This
painting was first in the possession of the sculptor
Geoffroy-Dechaume who lent it to Daumier's exhibition in
1878. Daumier himself used the composition again: one
lithograph, published in Bertaut's *Souvenirs d'Artistes* (1862) is
an exact copy; another, published in the series *Actualités
Politiques*, in *Le Charivari*, 21 January 1867, was entitled *Two
Friends* and transposed the two combatants into a Turk and a
Cretan struggling in the desert. The same story with its
ironic moral appears in one of Daumier's earliest
lithographs (Plate 2), and Millet too is known to have
painted the same scene in 1867, a work which has since
disappeared.

THE LAW

Daumier designed thirty-nine plates for a series of legal scenes entitled *Men of Justice*. Thirty-seven of these scenes appeared in *Le Charivari* between 21 March 1845 and 31 October 1848. Among his most successful prints, they depict all the worst aspects of French nineteenth-century legal affairs, already superbly satirized by Balzac in his series of novels *Scènes de la vie parisienne*. Daumier's own trial on account of the lithograph *Gargantua* (Plate 1) and that of his editor, Philipon, were fully reported in *La Caricature* in 1831–32. These detailed accounts, written by Philipon himself, may have provided the inspiration for Daumier's legal lampoons. Philipon evolved a satirical style which was intensely visual; he used amazingly intricate sentences with piled-up subordinate clauses in conjunction with sudden snappy phrases, off-stage noises and vivid images. In passages of mock-seriousness Philipon satirized complicated legal proceedings with enormous verve, and later he probably wrote many of the captions to Daumier's legal caricatures. The artist's designs are also effective; spare and vivid, these images often make the captions seem unnecessary. Occasionally the pictures have sinister, even horrifying ramifications.

These cartoons probably anticipate the series of drawings and paintings in which the physiognomies of lawyers and their limited stock of gestures are set against the figures they defend or prosecute: a poor widow (Plate 24), a hardened criminal with a deformed skull (Plate 27), or the accused in a murder trial (Plate 26). One striking feature of Daumier's legal scenes is his evident knowledge of the Palais de Justice itself, one of the most famous buildings in Paris (fig. 4). From 1829 to 1833 the artist lived with his parents in the rue de la Barillerie, just opposite the Palais de Justice, and he evidently remembered details of the building very clearly. Sometimes he set scenes in the Salle des Pas Perdus (Plate 21) or in the Central Criminal Court (Plate 26). But the area of greatest importance in the nineteenth century was the great flight of steps leading down to the entrance courtyard (Plates 23, 25 and fig. 4) where official guides waited to show foreign visitors round the building. Described in Balzac's novel *The Rise and Fall of César Birotteau*, published in

1837, this stairway also formed the subject of Daumier's most memorable legal lithograph (Plate 23) and several drawings (Plate 25). The emphasis which the artist placed on this one building with its frightening reputation implies that many of his legal pictures shared the popular appeal of his train and omnibus scenes (Plates 76–82 and 60), his paintings of *Don Quixote* (Plates 87–92) and the lithographs of famous exhibitions and public events (Plate 39).

There are over one hundred and thirty known drawings of lawyers by Daumier, some half-dozen attributed drawings and about twenty-five authentic paintings, seven of which appeared at the 1878 exhibition. Daumier's greatest achievement in legal imagery, however, is the finished watercolours which he made to attract a lucrative market, probably in the early 1860s (Plates 25 and 27). Many of these appeared in Daumier's 1878 exhibition and aroused immense critical enthusiasm. Castagnary, in his review of the exhibition which appeared in *Le Siècle* on 25 April 1878, was especially struck by Daumier's court scenes. He felt that they summarized the artist's unique perception: 'Daumier is not, strictly speaking, a caricaturist. Above all, he is a powerful observer, a moralist for whom human nature, the length and breadth of human beings, has no secrets'. Duranty, who also reviewed the exhibition, noticed how the gestures and expressions of lawyers, their clients and the public often turned up again and again in other, quite different subjects by Daumier; how groups of people, who push each other out of the way to see what is going on, parade the same characteristics whether they watch a play, an exhibition or a trial. Certainly Daumier's greatest religious work, *We want Barabbas!* (Plate 19), combines all the features of public spectacle and of trial scene, and many of his most eloquent lawyers may have developed from the images of Christ's detractors in this picture.

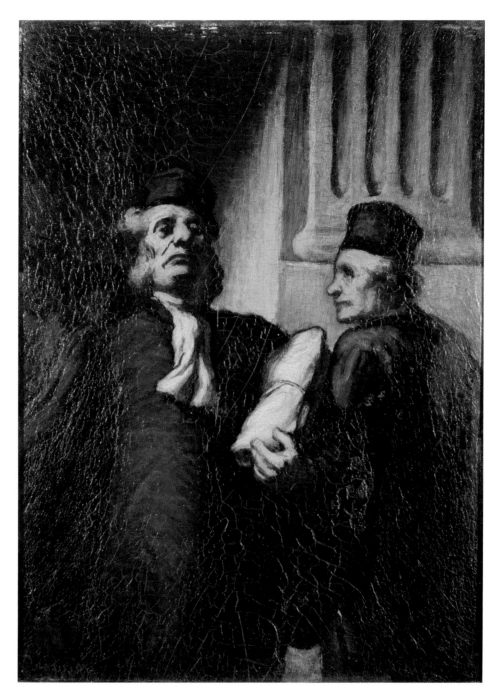

21 *Two Barristers* (*Les deux avocats*) or *After the Hearing* (*Après l'audience*) or *A Corner of the Palais de Justice* (*Un coin du Palais*) (see page 44).

LYON, Musée des Beaux-Arts. c. 1848. Oil on panel 34 x 26 cm. Signed bottom left: h.Daumier.

This painting, probably the earliest by Daumier of a legal subject, may be set in the Salle des Pas Perdus, identifiable from the large, pearl-grey pilaster behind the figures. The principal barrister was to become a familiar figure; plump and imposing, he dominates many of Daumier's *Men of Justice* series of lithographs (Plates 22 and 23), the later watercolour of *The Grand Staircase of the Palais de Justice* (Plate 25) and appears in one or two single figure studies (e.g. Switzerland, Remarque collection). Exhibited in 1878, this painting was owned by Daubigny, who left it to his wife after he died in 1878. It has been considerably damaged by bitumen and oil varnish. Daumier later made an almost identical watercolour (Rheims, Musée des Beaux-Arts) but without the architectural background, which was also exhibited in 1878.

(above left)

22 *Men of Justice* (*Les gens de justice*), number thirty-five
PARIS, Bibliothèque Nationale. *Le Charivari*, 27 April 1848.
Lithograph 23·9 x 18·3 cm. Initialled bottom left: h.D.
(H. & D. 1882).

The caption reads: 'Yes I know you've lost your case but
surely you enjoyed listening to the eloquent way in which I
lost it.' ['Vous avez perdu votre procès c'est vrai . . . mais
vous avez dû éprouver bien du plaisir à m'entendre plaider.']
The figure of the widow and her son reappear in one of
Daumier's later drawings (Plate 24). An oil painting entitled
La cause perdue (Eragny, Cordey collection) is thought to be a
copy of this lithograph and not by Daumier.

(above right)

23 *Men of Justice* (*Les gens de justice*), number thirty-six: *Grand
Staircase of the Palais de Justice* (*Le Grand Escalier du Palais de
Justice*)
PARIS, Bibliothèque Nationale. *Le Charivari*, 8 February
1848. Lithograph 24 x 18 cm. Initialled bottom left: h.D. (H.
& D. 1883).

This is another of Daumier's newspaper cartoons which was
used again by the artist many years later in a commercial
drawing (Plate 25).

24 *At the Palais de Justice* (*Au Palais*) or *After the Verdict*
(*Après le verdict*)
PARIS, Musée du Petit Palais. Possibly early 1860s. Crayon,
wash and watercolour 14 x 23 cm. Signed bottom left:
h.Daumier.
This finished drawing relates to several previous works: the
widow and child on the right appear in a lithograph from *Le
Charivari* of 1848 (Plate 22) and the two central barristers in
a number of drawings similar to *A Confidential Matter* (Plate
29). However, Daumier gave a deeper sense of tragedy to
these standard situations. The contrast between the figures,
their gestures and expressions, is deliberately provocative.
Several lithographs from the *Men of Justice* series in *Le
Charivari* show advocates arguing with members of the
public or trying to placate them. Usually these ordinary
people have been swindled and cannot understand why.
Here the widow and her child are, like the washerwoman in
The Heavy Burden (Plate 54), figures who seem to symbolize
suffering and oppression throughout Daumier's more
private works.

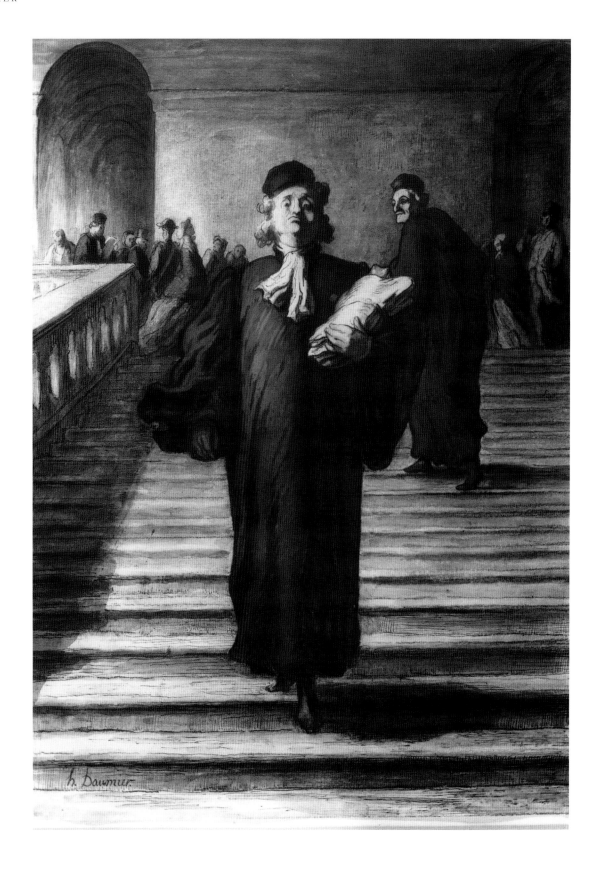

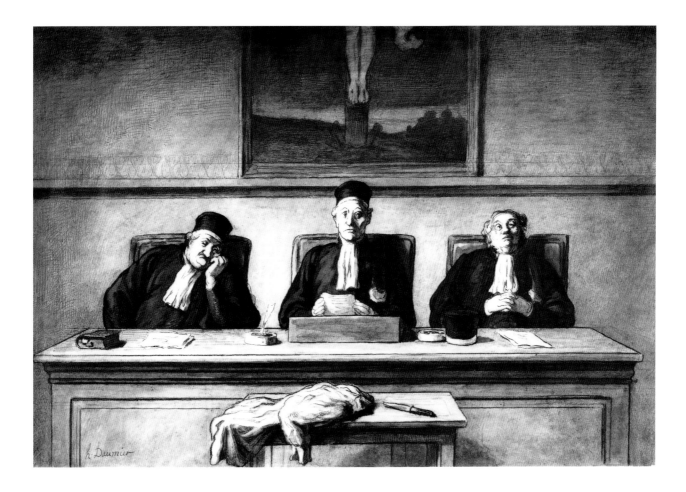

(opposite)

25 *The Grand Staircase of the Palais de Justice*
(*Le Grand Escalier du Palais de Justice*)
BALTIMORE, Baltimore Museum of Art (George A. Lucas
collection, on loan from the Maryland Institute). c. 1864.
Pen and ink over crayon and watercolour heightened with
gouache 36 x 26·6 cm. Signed bottom left: h.Daumier.
This watercolour was bought by the American collector G.
A. Lucas, probably in 1864 (see Plates 60 and 77–79). The
design is an almost exact reproduction of Daumier's famous
lithograph (Plate 23). There is an oil painting of similar
design entitled *L'avocat triomphant* in the Boston Museum of
Fine Arts.

26 *The Incriminating Evidence* (*Les pièces à conviction*)
MELBOURNE, National Gallery of Victoria (Felton bequest).
Wash and watercolour, gouache and red and black chalk 32·4
x 47 cm. Signed bottom left: h.Daumier.
This scene may well be set in the Central Criminal Court of
the Palais de Justice [Première Chambre de la Cour d'Assise]
in which hung, in the 1860s, a painting thought to be part of
a Calvary by Van Eyck. Here the case would seem to be one
of murder because of the evidence exhibited on the stand.
The three judges resemble some of the figures in *The
Legislative Belly* (Plate 9) and may derive from eighteenth-
century caricatures of judges such as Hogarth's famous
print *The Bench* (fig. 2). There is another, less finished version
of this work in a Munich private collection.

27 *A Criminal Case* (*Une cause criminelle*)

LONDON, Victoria and Albert Museum, Department of Prints and Drawings. Pen, ink and crayon over charcoal 19 x 29 cm. Initialled and dedicated bottom left: h.D. à Monsieur Pléz [?Ples].

The criminal, whose skull is drawn in thick outlines, forms a contrast with the thin nervous lines of the barrister. An almost identical drawing in a Paris private collection shows both lawyer and client reduced to pure outline. This is one of several drawings to show consultations taking place in court between barristers and their clients or members of the jury, and in every version the enquirer carries a hat. The situation obviously offered Daumier an opportunity of exploiting his skill as a designer of exaggerated physiognomies, a trait especially noticeable when the defence counsel embarks upon an impassioned plea (Plate 28). In *Le Charivari* of 23 February 1845, Daumier depicted a similar situation in which a thief, who has just been acquitted, actually picks his barrister's pocket from the dock.

28 *The Counsel for the Defence* (*Le défenseur*)
LONDON, Courtauld Institute Galleries. Pen and
wash over pencil 22·5 x 30 cm. Initialled right: h.D.
There is an almost identical drawing in a German
private collection and both may relate to a large,
unfinished oil of the mid-1860s entitled *The Pardon*
(Rotterdam, Museum Boijmans-van Beuningen).

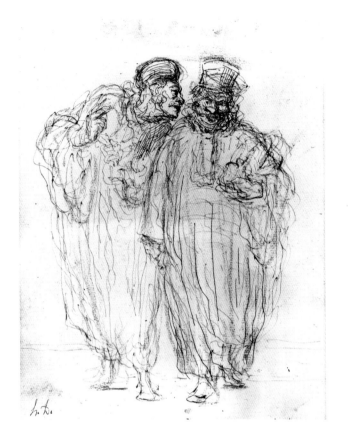

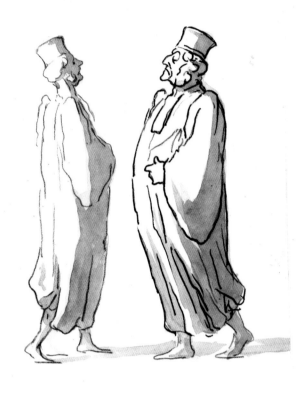

(above left)

29 *A Confidential Matter* (*Une confidence*) or *Two Barristers* (*Deux avocats*)

LONDON, Victoria and Albert Museum. Pen, black and red ink over charcoal 23 x 18·5 cm. Initialled bottom left: h.D. One of four studies of barristers in this particular attitude, this is the penultimate sketch for a more finished watercolour (Germany, private collection), executed on the verso of another watercolour showing a butcher in Montmartre. Here Daumier used three different types of medium to describe quite separate areas: chalk underdrawing outlines the preliminary contours, red ink fills in the details and black ink inserts the areas of direct expression such as the hats, the features of the faces and the hand of the barrister on the right. The figures therefore emerge from a complicated web of lines in which Daumier explored all their pictorial possibilities. They also resemble the designs he made for the theatrical personalities Crispin and Scapin (Plates 38 and 39).

(above right)

30 *Two Barristers* (*Deux avocats*)

LONDON, Victoria and Albert Museum. c. mid-1860s. Pen and ink 20·5 x 29·5 cm. Unsigned.

Another of Daumier's nervous pen drawings, here the lines track the movements of the two figures rather than their substance or features. Daumier was a very open artist, and in drawings like these the spectator can see all his processes of building up shapes and gestures, the lines which he discarded and those he chose to emphasize. These barristers are thought to have been used by Daumier in a lithograph published in *Le Journal Amusant* on 3 March 1866.

CHARLATANS, MOUNTEBANKS, MELODRAMA AND COMEDY

Theatrical scenes and studies of street performers often appeared in popular books of collected lithographs in the 1830s. Made by artists such as Forest, Arnoult and Grandville, they were published by Aubert, the printer of *La Caricature* and *Le Charivari*. Images of mountebanks also formed headings or decorations in popular newspapers, suggesting that the contents were a rag-bag of ideas and information which could be humorous, moving or tragic. Even the first issue of *Le Charivari* had an illustration by Forest of a mountebank advertising the paper. Daumier's first mountebank lithographs appeared in *Le Charivari* in 1838, two years after Philipon devised the Robert Macaire cartoons (Plate 31). In paintings, drawings and lithographs Daumier constantly made use of theatrical imagery, as did many nineteenth-century artists. By 1853 paintings of mountebanks were appearing at the official Salon, and in 1861 Madame Sabatier sold a panel painting by Meissonier of a *Pulchinello* to the fourth marquess of Hertford for 13,000 francs.

Theatrical subjects were also to become the staple imagery of Renoir, while Degas, Seurat and Toulouse-Lautrec immortalized the Paris stage and café-concert in their pictures. Daumier anticipated many of these later developments of theatre scenes in some forty paintings and numerous watercolours and drawings. He often exploited the language of situation comedy from the Paris music hall in his lithographs, and his paintings show the extent of his knowledge of the French stage. His pictures can be divided into distinct categories of subject matter: professional and amateur musicians, strolling players, buskers and mountebanks; studies of theatre audiences from all sections of the auditorium; actual performances, from Molière (Plate 37) to low-class melodrama (Plate 36). The performers include favourite clowns such as the rascally valets Crispin and Scapin (Plates 38 and 39), professional wrestlers (Plate 35), jugglers and the strong man (Plate 34). The lower their position in the hierarchy of players, the more Daumier chose to emphasize their personalities. At the exhibition of 1878 the critic Castagnary was especially struck by one of Daumier's watercolours of mountebanks (Plate 33). In his review which appeared in *Le Siècle* on 25 April 1878 he wrote: 'We know nothing sadder or more poignant than Daumier's mountebanks . . . a great writer who wished to interest us in these splendid people and introduce us to the miseries of their existence would have some trouble in obtaining such a moving effect.'

31 *Robert Macaire: Investment Counsellor*
(*Robert Macaire: agent d'affaires*)

LONDON, British Museum, Department of Prints and Drawings. *Le Charivari*, 20 November 1836. Lithograph 25·4 x 20·8 cm. Unsigned. Inscription on left margin: Ch.Ph.invt. H.D.lith. (H. & D. 1001).

The caption reads: 'I was wrong when I said just yesterday that this was a good investment. It's a rotten one. It's true the government owes you five hundred thousand francs but as they haven't acknowledged the debt you won't get a penny. – But, come to think of it, there's Mr de St Bertrand, a rich capitalist and a fool, sell him all your rights for one hundred écus and that will be an excellent investment – (aside) and a cheap one!' ['Hier je me suis trompé en disant que votre affaire est bonne, elle est détestable. Le gouvernement vous doit cinq cents mille francs, c'est vrai; mais la créance n'a pas été reconnue, il y a aujourd'hui, déchéance, vous n'aurez pas un sou. – Cependant, tenez, j'y pense, voici Mr de St Bertrand, un riche capitaliste, un imbécile; vendez lui vos droits cent écus, ce sera une affaire magnifique . . . (à part) et pas chère . . .']

One of the series *Caricaturana*, written by Philipon and drawn by Daumier, this work is one of many to portray the swindler Robert Macaire. Originally a bandit in a three-act melodrama entitled *L'auberge des Adrets*, first performed in 1823 at the Ambigu Comique in Paris, 'Robert Macaire' became an immortal personality. The melodrama was abandoned; Frédéric Lemaître, who had starred as Macaire, succeeded in creating a new character out of the original rôle, an episode which forms a crucial scene in Marcel Carné's 1945 film, *Les enfants du paradis*. By 1834 Robert Macaire had emerged as a universal trickster, accompanied by his stooge, the emaciated Bertrand, who does all the dirty work but never gets any of the loot. Frédéric Lemaître continued playing Macaire in countless comedies, melodramas and farces. He often inserted observations of a political nature as asides in the prepared scripts, which led to the Robert Macaire plays being briefly banned in 1835. As an obnoxious anti-hero, Macaire remained popular in France throughout the nineteenth century. Daumier drew 101 Macaire scenes to captions written by his editors Philipon, Maurice Aloy and Louis Houard. The lithographs appeared in *Le Charivari* between 1836 and 1838 and showed Robert Macaire in numerous professions, actor, painter, surgeon, detective, matrimonial agent, speculator, politician, cheating his way to success in all of them. Here the scene is set behind the Bourse. Bertrand, disguised as a respectable but foolish capitalist, trudges warily past Macaire and his potential victim, a rather sceptical bourgeois investor. The swindler wears his original bandit's mask but retains, as always, the features of the great actor, Frédéric Lemaître, his virtual creator.

32 *The Mountebanks (Les saltimbanques)*

LONDON, British Museum, Department of Prints and Drawings. *La Caricature* (second series), number twenty-five, 21 April 1839. Lithograph 27·8 x 21·8 cm. Initialled bottom right: H.D. (H. & D. 373).

The caption reads: 'We're sunk Bilboquet. Those smart Alecs will swipe our public.' – 'Don't worry Gringallet. That's not competition, it's just a variety act!!!' ['Ô maître Bilboquet, nous sommes flambés, ces farceurs là vont nous prendre notre public.' – 'Ne crains rien Gringallet. Ce n'est point de la concurrence, c'est de la haute comédie!!!']

This is the first of two plates published on 21 and 28 April 1839, which were republished in *Le Charivari* in 1843. Daumier used this particular composition as the basis for a later drawing which shows dispirited clowns whose audience has flocked to see another entertainment (Plate 33). Here the two mountebanks use a form of slang which derives from Napoleonic army language. The cup and ball in the foreground refer to the name of the master performer, 'Bilboquet', meaning, literally, the game of diabolo. In the distance a group of people surround a number of upstart performers, one of whom is balanced on stilts and holds up a placard inscribed: '1000000 MILLION SOCIETE . . . (COMMERCE? COMMISSIONS?)'. A lawyer stands on his hands, another figure drums and the spectators offer them money. The building in the background is the Bourse where Robert Macaire (Plate 31) sometimes carried out financial swindles. In 1848 the first issue of a small, short-lived newspaper, *Les Saltimbanques*, contained an article entitled 'The Lamentations of Bilboquet', which satirized French monetary practice, especially the financing of huge international loans. Comparisons between financiers and jugglers, mountebanks and tricksters are still common but probably the most brilliant description of financial swindlers appeared in Balzac's novel *La Maison Nucingen* published in 1838, the year before Daumier's cartoon.

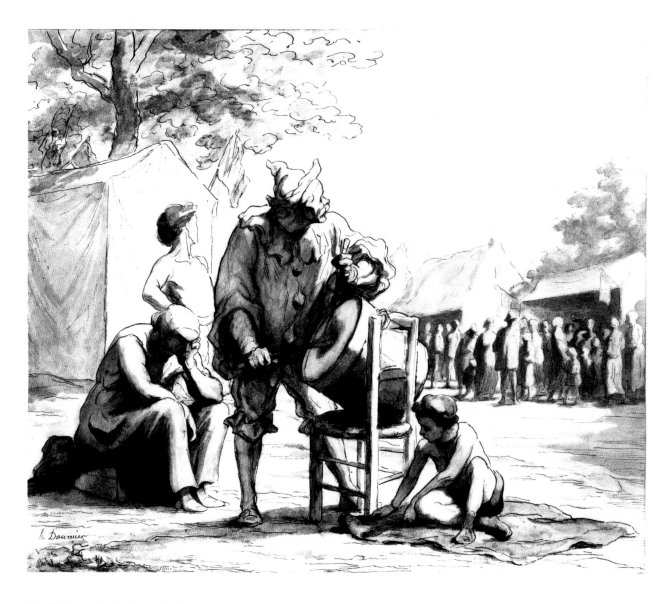

33 *The Mountebanks* (*Les saltimbanques*)
LONDON, Victoria and Albert Museum. c. 1860s. Pen and
watercolour 33 x 40 cm. Signed bottom left: h.Daumier.
Daumier's first biographer, Alexandre, listed this drawing in
1888 when it was in the collection of the English business
tycoon, C. A. Ionides. It was exhibited in 1878 and praised
by Castagnary in *Le Siècle* of that year. The seated figure on
the left relates to another, more finished drawing in a French
private collection, in which a pierrot collapses exhausted
behind a tent after the performance. The boy with his cap
also appears in the watercolour of the drumming buffoon in
the British Museum (Plate 40). These drawings of weary
street performers seem to be related and may all date from
the same period.

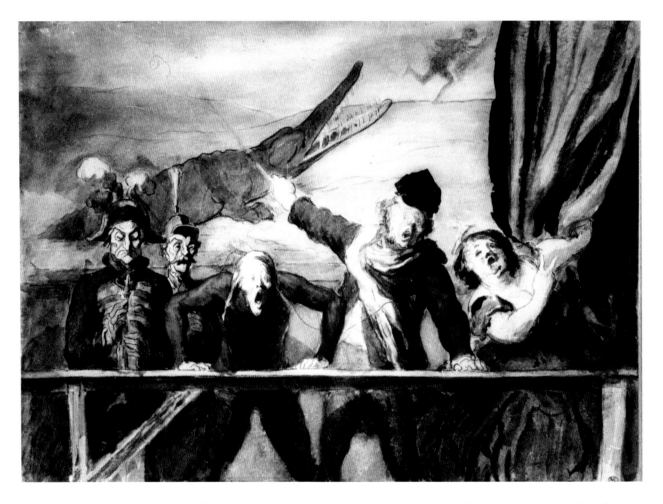

34 *The Parade* (*La parade* or *La parade foraine*)
PARIS, Musée du Louvre. Crayon and traces of sanguine and
watercolour 26·6 x 36·7 cm. Initialled bottom left: h.D.
First owned by Dumas fils, this work was exhibited in 1878
and appeared again at the Dumas sale in 1882. There is a
tiny oil study of the barker on the left (Cambridge,

Massachusetts, private collection) and two drawings for the
whole composition (Budapest, Szépmüvészeti Museum; and
formerly Bureau collection, present whereabouts unknown).
In 1877 an unsigned woodcut of this watercolour was
reproduced in *Galerie Contemporaine*, illustrating an article
about Daumier by Aristide Ménandre.

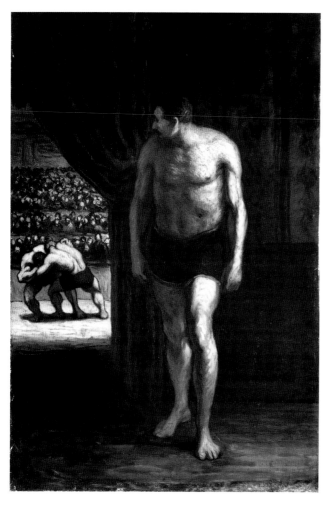

35 *The Wrestlers (Les lutteurs)*
COPENHAGEN, Ordrupsgaardsamlingen, c. 1848–52. Oil on panel 42 x 27·5 cm. Signed bottom left: h.Daumier.
The modelling of the principal figure in this work is uncertain, particularly around the shoulders, and there is a noticeable *pentimento* on the right foot. The distant wrestlers in the arena are painted quite differently, with much more assurance, and it is consequently difficult to date this picture exactly. The majority of Daumier scholars see it as an early work, but their date of c. 1852 would make it later than the more accomplished and confident painting *The Miller, his Son and their Ass* (Plate 18). There is one preparatory drawing for the whole composition (Vienna, Graphische Sammlung Albertina) and three drawings of the two wrestlers in the background (two in Lyon, Musée des Beaux-Arts; and one, formerly Roger-Marx collection, Paris, present whereabouts unknown). From these it appears that Daumier was very interested in Greco-Roman wrestling. He drew several classical body holds and one wrestling throw and ends up, in the painting, with another classical body hold often represented on ancient amphorae. The crouching position of the figures with bent knees is not unlike that of the well-known pair of wrestling boys in the Museo Nazionale di Capodimonte, Naples. This particular hold comes at an early stage in the contest which suggests that the wrestler in the foreground has just finished his bout and is turning to watch the next part of the programme. In the late 1850s and 1860s the Cirque de l'Impératrice and the Hippodrome were probably the best places in Paris to watch wrestling and other types of gymnastic performance, although the latter specialized in putting on spectacular acrobatic performances and balloon ascents. Works of this type by Daumier, in which the handling of the paint is almost primitive, seem to have attracted the attention of other artists, rather than that of dealers or collectors. Owned first by Daubigny, the painting was exhibited in Paris in 1878 and again in 1901. The foreground wrestler is remarkably similar to Cézanne's *Bather* (New York, Museum of Modern Art) which suggests that Cézanne too was interested in Daumier's muscular figures.

36 *The Drama* (*Le drame*) or *In the Theatre* (*Au théâtre*) or *The Melodrama* (*Le mélodrame*)

MUNICH, Neue Pinakothek. c. 1860. Oil on canvas 97·5 x 90·4 cm. Signed bottom left: h. Daumier.

Exhibited in 1878 when still in Daumier's studio, this picture was still in the possession of Daumier's widow in 1888 according to Arsène Alexandre, which suggests that it could not be sold. However in 1907 the dealer Bernheim bought the picture for 28,000 francs and it has since been restored. The same design appeared in a lithograph in *Le Charivari* in 1864, the year after Daumier returned to newspaper work, and this painting may belong to a series of theatre and mountebank scenes which the artist produced in the early 1860s for commercial purposes (Plates 33 and 40). This particular composition is almost unique because Daumier's theatrical subjects usually portray either the actors or the audience, but here both appear. In some of these pictures it is possible to identify the theatre, the play and the area of the auditorium: nineteenth-century Paris theatres were ranked as part of a distinct hierarchy according to the type of entertainment performed in them, and there could be as many as eighteen different seating arrangements and prices. In this painting the character of the audience and the play itself provide clues to the type of theatre portrayed: the audience is low-class, the play a gothic melodrama. Both details suggest that Daumier had a specific theatre in mind, in this case, probably, the Théâtre de la Porte Martin, apparently the most capacious theatre in Paris in the 1860s which put on melodramas, spectaculars and all kinds of exaggerated tragedies for the lower classes. In his description of this picture Arsène Alexandre says that Daumier's viewpoint was taken from the gallery, where seats cost an average of one and a half francs, a full day's wages for most of these spectators. There was an oil sketch on canvas, a doubtful work which has recently disappeared.

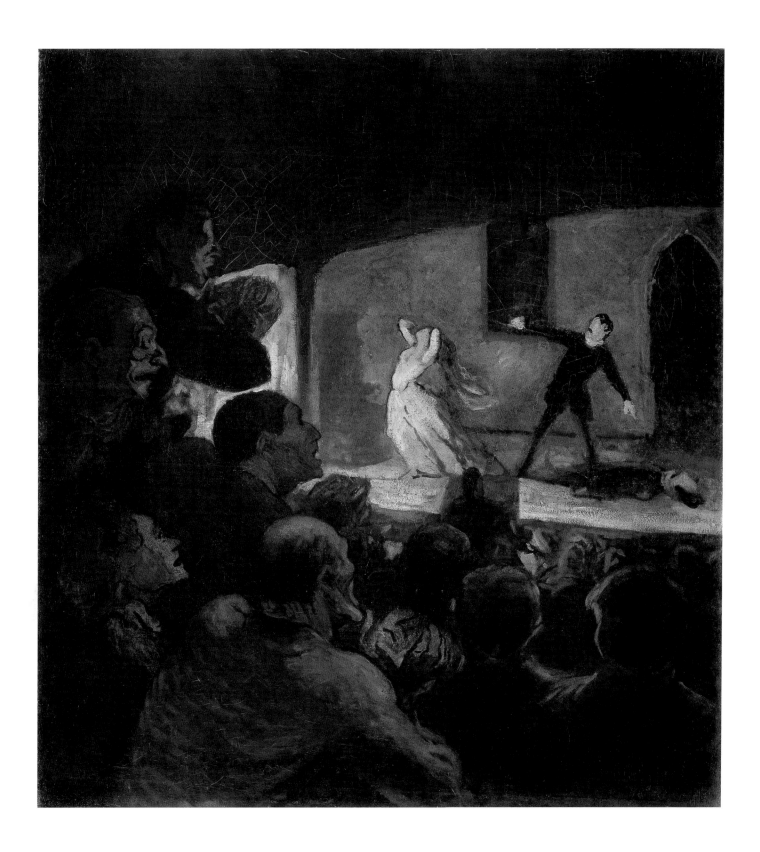

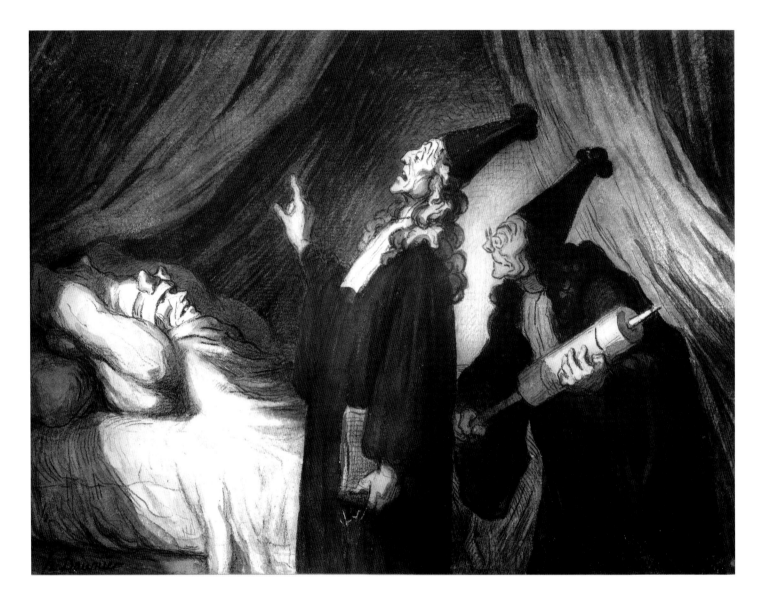

37 '*Le malade imaginaire*'
LONDON, Courtauld Institute Galleries. Charcoal, crayon
and watercolour 19·5 x 26·6 cm. Signed bottom left:
h.Daumier.
Molière's comédie-ballet *Le malade imaginaire* was first
produced in 1673. The story concerns a nervous
hypochondriac who puts himself into the hands of two
sinister quacks, Purgan and Diafoirus. Daumier made four
drawings of this scene from the play, and in each of them
the features of the two doctors become more diabolic.
There are also two oils (Merion, Pennsylvania, Barnes
Foundation; and Philadelphia, Philadelphia Museum of Art).

38 *Scapin* (*Un scapin*) or *Scene from Molière* (*Scène de Molière*) or *Comic Scene* (*Scène de comédie*)

PARIS, Musée du Louvre. c. 1858–62.

Oil on panel 32·5 x 24·5 cm. Unsigned.

Scapin is the principal character in a comedy by Molière, *Les fourberies de Scapin*, first produced in 1671. A resourceful valet who aids his master's romance, he is shown in this picture with the aged Argante (or, possibly, Géronte) who is about to be swindled. There are two similar pictures; one is a companion piece (Cambridge, Massachusetts, Fogg Art Museum) and shows an almost identical Scapin with another character from the same play; the other (Plate III) makes the figure of the valet-clown into a heroic stage portrait. There are four preliminary drawings (Paris, Roger-Marx collection) which analyze particularly the contours of these figures. The thick, twisted lines of paint are analogous to later styles, and seem especially to anticipate the painterly brilliance of Edvard Munch (fig. 6). Both *Scapin* and *Scapin and Sylvestre* (Plate 39) were exhibited in 1878 when they were still in the artist's possession and bore the identical title of *Un scapin*.

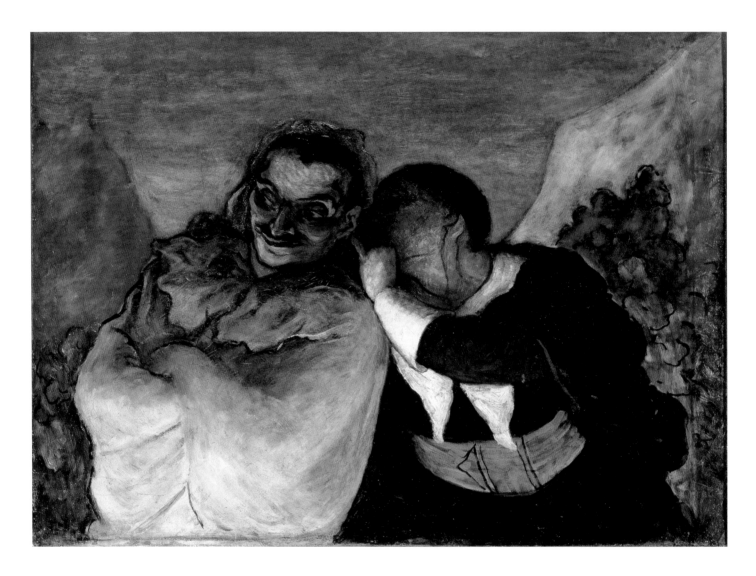

39 *Scapin and Sylvestre* or *Crispin and Scapin*
PARIS, Musée du Louvre. c. early 1860s. Oil on panel 60·5 x
82 cm. Initialled bottom left: h.D.
The subject of this painting has never been precisely
identified. It appeared at Daumier's 1878 exhibition when in
the possession of Madame Daubigny, under the title *Un
scapin* (see Plate 39). In 1888 it acquired another title, *Les
deux compères*. Later it became *Crispin and Scapin*, suggesting
that the subject was not taken from Molière but from a play
by Le Sage *Crispin rival de son maître*, which was first produced
in 1707. In this play two rascally valets appear. However, by

the nineteenth century three humorous scoundrels, Crispin,
Scapin and Sylvestre, had acquired the same kind of
independence of character as Robert Macaire in the 1820s
(see Plate 31). From c. 1840 to c. 1860 numerous vaudevilles
and satirical verse plays appeared in Paris, in which these
valets were shown in many new comic situations. It is
possible that Daumier's interest did not come from the
authentic masterpieces by Molière and Le Sage but from
these curious later adaptations. There is an oil sketch for this
painting in Boston (Remis collection).

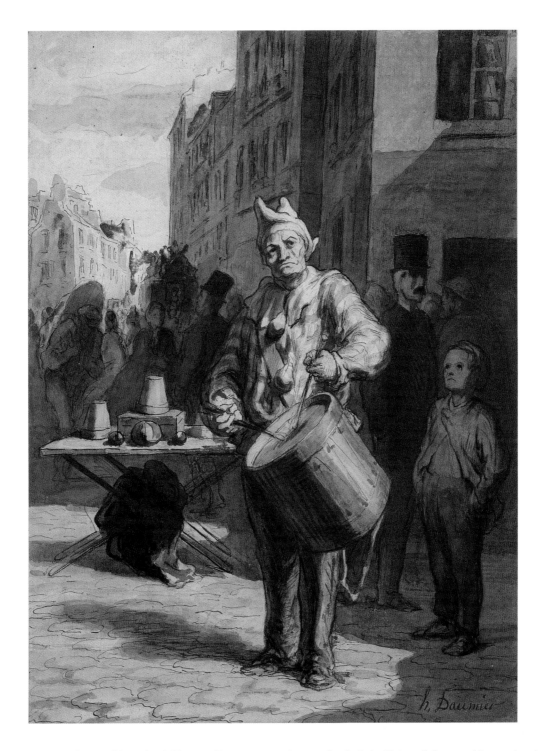

40 *The Buffoon (Le bateleur)* or *Mountebank Playing a Drum (Saltimbanque jouant du tambour)*
LONDON, British Museum, Department of Prints and Drawings. Possibly c. 1860s. Watercolour, ink, black chalk and white heightening 35·5 x 25·7 cm.
Signed bottom right: h.Daumier.
There are six preparatory sketches for this picture. Five show the drummer standing on a fairground in front of a picture of a fat lady. This and the penultimate sketch (New York, Metropolitan Museum of Art) place him against high, slanting, city tenements. The perspective corresponds to the steep mountain pass in *Don Quixote and the Dead Mule* (Plate 92) and strongly resembles stage scenery. A painting of mountebanks resting (Los Angeles, Norton Simon Collection) includes another figure with similar facial features and is dated in the mid-1860s.

41 *Pierrot Playing a Mandoline* or *Guitar*
(*Pierrot jouant de la mandoline*)
WINTERTHUR, Oskar Reinhart Collection 'Am Römerholz'.
c. 1870–73. Oil on panel 35 x 26·5 cm.
Initialled bottom left: h.D.
Thought to be based on a *figure de fantaisie* by Fragonard,
probably the *Portrait of M. de la Bretèche* which was given to
the Musée du Louvre by Louis La Caze in 1869, this is
among Daumier's last paintings. The colours are warm: the
lines describing the Pierrot form a maze of thick cream
striations placed over a background of brown, gold and

scarlet. Daumier outlined the contours in black but the lines
are thick and seem almost clumsy, perhaps demonstrating
how bad the painter's failing eyesight had become. The thick
wobbly marks all over the picture may have been painted as
an attempt to emulate Fragonard's impasto, but the result is
far from the eighteenth-century artist's spontaneous skill.
Daumier's broken brushwork in this picture is not at all
spontaneous; he 'rehearsed' the effect in another, much
smaller preparatory oil panel (whereabouts now unknown).
This painting was exhibited in 1878.

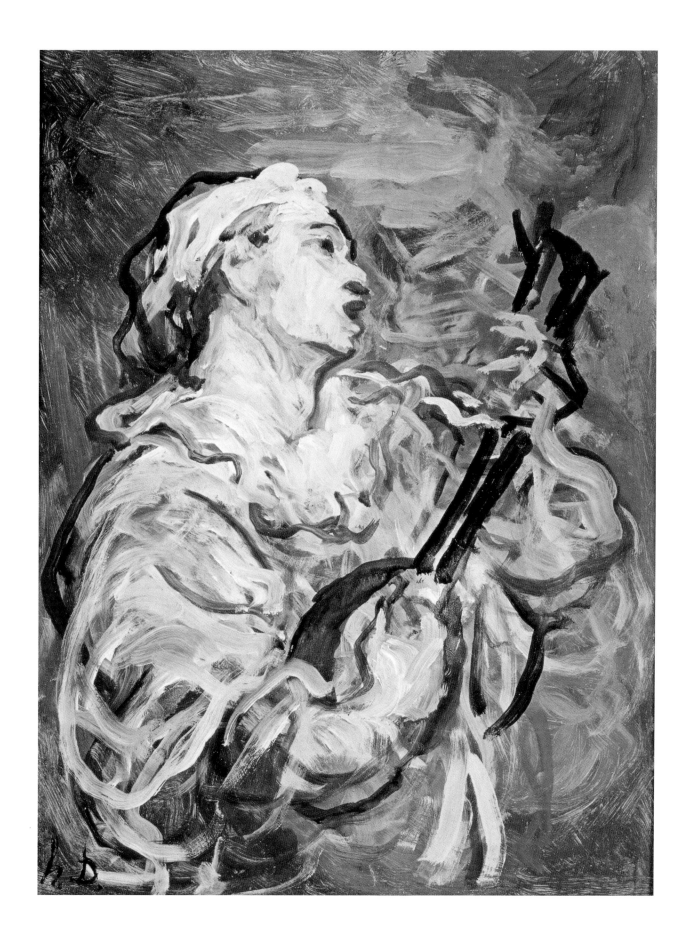

ARTISTS AND COLLECTORS

Throughout his journalistic career, Daumier often returned to a subject which was evidently popular among the readers of *Le Charivari*: Parisian artistic life. Numerous lithographs with titles such as *The Public at the Salons* or *Scenes from the Studios* are still favourites and they explore many aspects of artistic practice in the nineteenth century, especially the artist's relationship with his patrons and public. Even in this apparently innocuous subject the influence of political policy appears. Daumier's earliest 'artistic' lithograph in *Le Charivari*, dated 6 May 1833 and showing two artists trying to keep warm in a freezing studio by dancing, bore the caption: 'Wood is dear and art doesn't pay.' Philipon explained that under the reign of Louis Philippe the arts had become 'wretched and abandoned'. This may have been a reference to the demonstrations and protests mounted by state artists after the 1830 revolution to demand the continuation of the civil list as it had been promised by the deposed Charles X. Louis Philippe himself was very interested in becoming a patron of the arts, but sometimes had difficulty in obtaining ministerial approval for his projects. After the revolution of 1848, the provisional government immediately put in train a number of state schemes to encourage the arts (Plates 15 and 16), but under Napoleon III the Salon jury became very doctrinaire and the history of French painting of the period is punctuated by the famous disputes between the establishment and avant-garde figures such as Courbet and Manet. Daumier's prints reflect all these artistic problems and conflicts: they attacked Louis Philippe's patronage in the 1830s and indicted the strictness of the jury in the 1840s (Plate 42). Under Napoleon III and even in the 1870s, the policy of *Le Charivari*, in conformity with accepted standards, was to restrict itself to attacks on Courbet, Manet and, later, the Symbolist artist, Gustave Moreau. It is significant that *Le Charivari* printed the most damning critical review of the first Impressionist Exhibition in 1874, but four years later published a eulogy of Daumier's personal exhibition at Durand-Ruel's gallery. Daumier's personal attitude towards his fellow-artists may have been quite different. His greatest friends were the landscape painters Corot

and Daubigny, but in lithographs Daumier was paid to lampoon *plein air* painters and wage a merciless campaign against landscape artists generally.

Another favourite subject was the behaviour of people in galleries and at exhibitions (Plate 47), and Daumier juxtaposed those who claim to know everything about art, and usually get it wrong, with those who gape uncomprehendingly. In Daumier's private work artists and collectors are portrayed more sympathetically. There are nearly forty drawings and watercolours and about another thirty-seven oils showing painters, draughtsmen, sculptors, spectators, collectors and connoisseurs. These were subjects which fascinated Daumier and he probably regarded them as profitable too. Pictures of artists in their studios were popular in France throughout the nineteenth century: before c. 1850 Salons were sometimes dominated by representations of the great artists of the past, shown in quite imaginary situations. By the middle of the century the emphasis had changed. The Salon of 1853 had six atelier subjects and only one portrayed that of an Old Master, C. Marchal's *Van Dyck in the Studio of Rubens*. There was even one picture of an *amateur d'estampes*, by A. E. Plassan. However the painter who probably made the most money from subjects of 'artists and collectors' was Meissonier who produced them throughout his career. Many of his scenes are period pieces but without their superficial historical trappings they are not unlike the kind of picture which Daumier made in the 1850s and 1860s (Plate 44). Meissonier depicted figures poring over drawings or prints in the corners of darkened studios (fig. 14). Daumier's earliest painting of an artist may have been a study of a draughtsman (St Louis, Washington University) which dates from around 1853–55. It is virtually impossible to date these works precisely, but they all show the great care Daumier took to complete them. For the finished oils or watercolours depicting an artist's studio there are often a number of preparatory sketches and even several versions of the same painting, as with Daumier's last picture of an artist (Plate 43), which may well be one of his rare self-portraits.

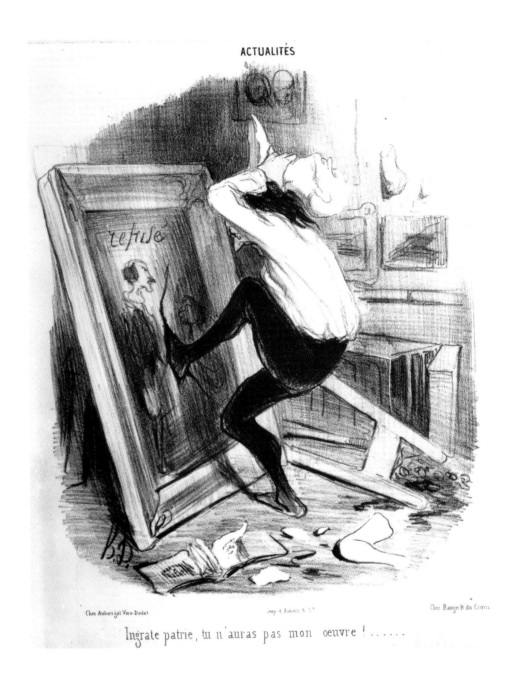

ACTUALITÉS

Ingrate patrie, tu n'auras pas mon oeuvre !

42 *Ungrateful Country, You Shan't Have my Masterpiece*! (*Ingrate patrie, tu n'auras pas mon oeuvre!*)
LONDON, British Museum, Department of Prints and Drawings. *La Caricature* (second series), number eleven, 15 March 1840. Lithograph 24·8 x 21 cm. Initialled bottom left: h.D. (H. & D. 312).
Daumier's cartoons often represented the hardships of unsuccessful artists. The word 'refusé' stamped across it shows that the painter's work has been rejected by the Salon.

This particular artist is a classical history painter who, as well as putting his foot through his canvas, is smashing a plaster cast of an antique figure, which may have provided a model for one of the figures in his painting; he has also torn up his sketchbook. The strict attitude of the Salon jury in the nineteenth century gave rise to ceaseless agitation on behalf of the rejected artists. Daumier himself tried to organize an independent exhibition in 1847 and protested against the jury in 1870.

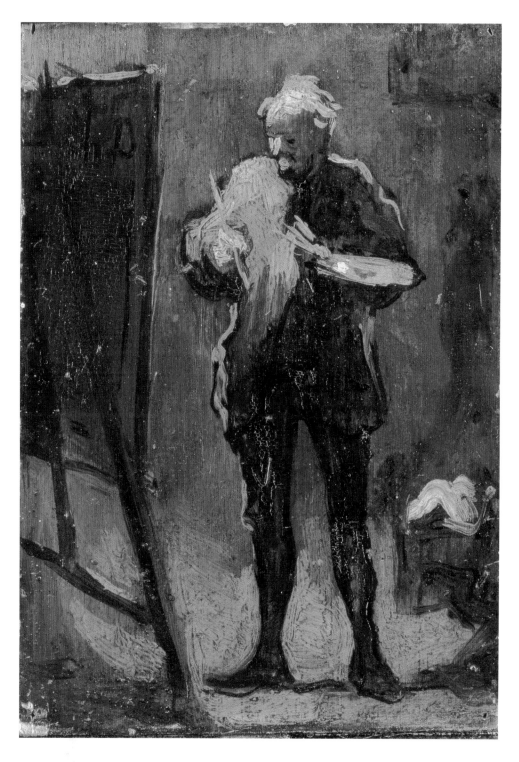

43 *The Painter in Front of his Picture*
(*Le peintre devant son tableau*)
WASHINGTON, Phillips Collection. c. 1870. Oil on panel 33·5 x 26 cm. Initialled bottom left: h.D.
This could easily be a self-portrait and the style corresponds to that of the *Don Quixote* panel in London (Plate 87). There is an earlier version of this painting in the Musée des Beaux-Arts, Rheims, a contemporary panel almost identical to this one in America (Williamstown, Sterling and Francine Clark Art Institute), and another oil sketch (Merion, Pennsylvania, Barnes Foundation).

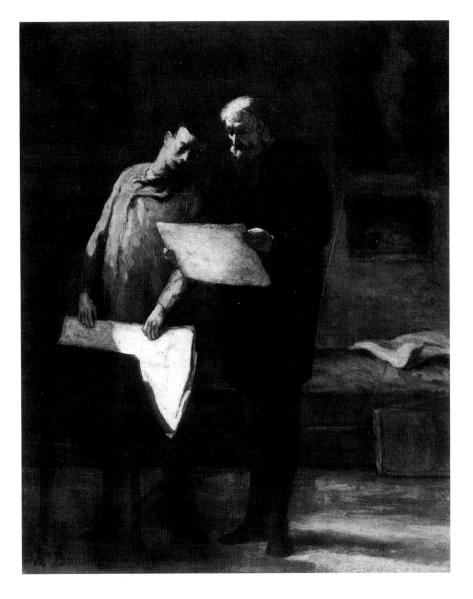

44 *Advice to a Young Artist* (*Conseils au jeune artiste*) or *Master and Pupil* (*Maître et élève*) or *The Amateur Print Collector* (*L'amateur d'estampes*)
WASHINGTON, National Gallery of Art (gift of Duncan Phillips). Early 1860s? Oil on canvas 39 x 31 cm. Signed bottom left: h.Daumier.
Originally owned by Corot, this painting was bought at the Corot sale in 1875 by Arthur Stevens, brother of the sculptor Alfred Stevens, for 1520 francs. Although it is not a costume piece, this work especially resembles the pictures of artists and connoisseurs which Meissonier exhibited at the Salon in the 1850s (fig. 14). Stevens also collected Meissonier's work.

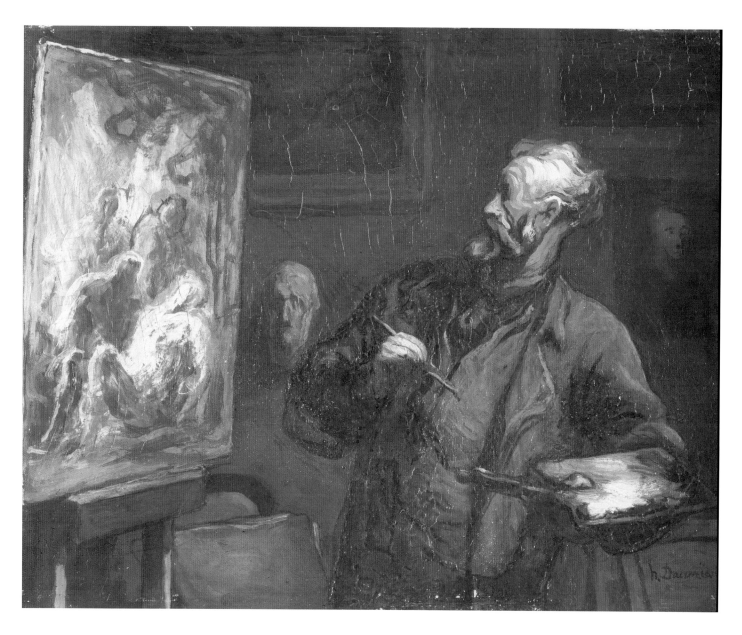

45 *The Painter* (*Le peintre*) or *The Entombment*
(*La mise au tombeau*)

RHEIMS. Musée des Beaux-Arts. Oil on panel 26 x 34 cm.
Signed bottom right: h.Daumier.

Although it has been suggested that the artist in this picture
was Daumier's friend, the landscape painter Jules Dupré,
portraits of Dupré show an entirely different man and there
is no record of Dupré having painted an Entombment.
Daumier himself attempted the subject in a painting

(formerly in the Hazard collection) of probably the same
approximate dimensions as those of the unfinished canvas
in this picture. The painter portrayed here strongly
resembles a figure by Rembrandt. *The Evangelist Matthew*
(Paris, Musée du Louvre), and also corresponds to other
pictures by Daumier of painters in their studios (Plates 44
and 49). There is a preliminary drawing of this painter in the
Roger-Marx collection, Paris, besides a number of copies
and forgeries elsewhere.

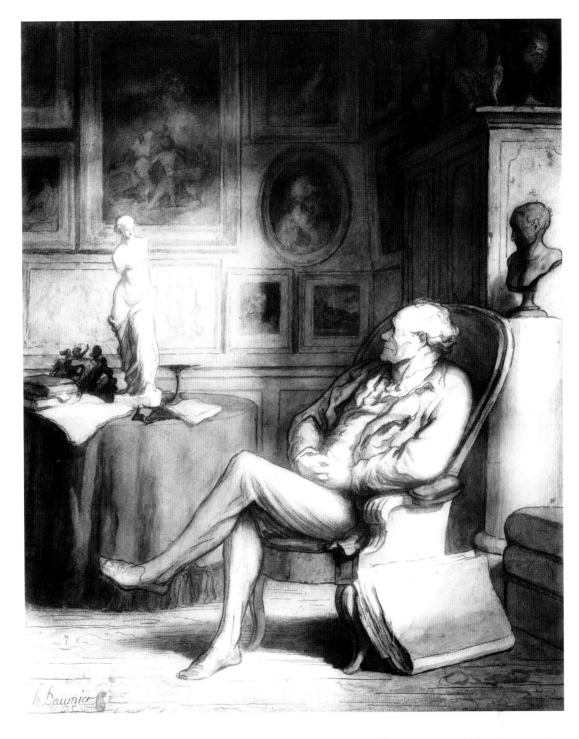

46 *The Amateur* or *The Connoisseur* (*Un amateur*)
NEW YORK, Metropolitan Museum of Art (bequest of Mrs
H. O. Havemeyer). Pencil and crayon, wash and watercolour
44 x 35 cm. Signed bottom left: h.Daumier.
This drawing fetched 1250 francs at the sale of Jules
Dupré's collection in 1890. Daumier evidently expended

much time and effort on its completion, because there are
two detailed sketches of the composition (Rotterdam,
Museum Boijmans-van Beuningen; and formerly Lemaire
collection, whereabouts now unknown). It was exhibited at
Durand-Ruel's in 1878.

47 *Les Bons Bourgeois*, number sixty-six: *A Real Connoisseur*
(*Un véritable amateur*)
LONDON. British Museum, Department of Prints and
Drawings. *Le Charivari*, 16 May 1847. Lithograph 25·6 x
20·2 cm. Initialled bottom left: h.D. (H. & D. 919).
One of many lithographs to depict people looking at
pictures, this print shows a figure quite unlike the poor
amateur in *L'amateur d'estampes* (Plate 59).

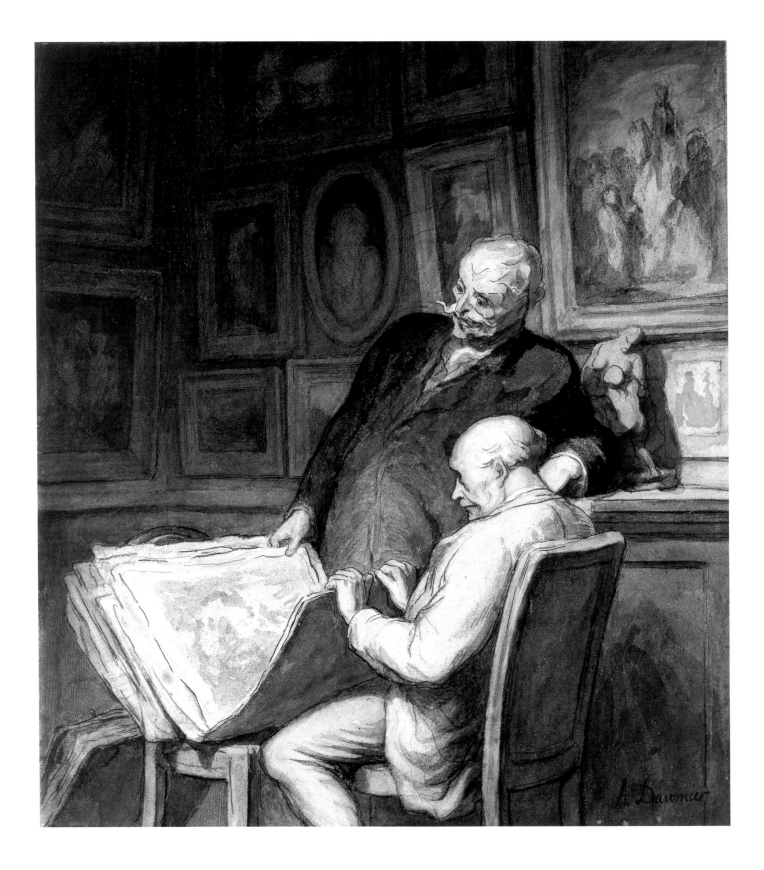

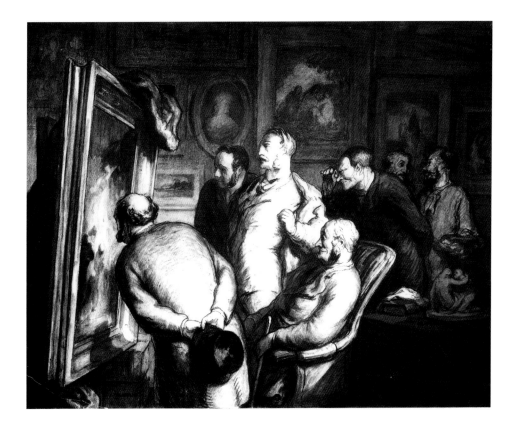

(opposite)

48 *The [Two] Connoisseurs (Les [deux] amateurs d'estampes)*
LONDON, Victoria and Albert Museum. Crayon, pen and
watercolour 35 x 32 cm. Signed bottom right: h.Daumier.
Different and more 'exalted' connoisseurs, these two figures,
examining a portfolio of prints in the rather hermetic
interior, recall such well-known minor collectors as Edmond
and Jules de Goncourt. Exhibited at Durand-Ruel's in 1878,
this watercolour is a highly finished work and may date from
the mid-1860s. There are several forgeries, one authentic
preparatory sketch (Buenos Aires, Museo Nacional de Bellas
Artes) and one tracing (formerly Scharf collection,
destroyed in the Second World War).

(above)

49 *Visitors to a Painter's Studio (Visiteurs dans l'atelier d'un
peintre)* or *Connoisseurs in a Studio (Amateurs dans un atelier)* or
The Critics (Les critiques)
MONTREAL, Museum of Fine Arts (bequest of Mrs W. R.
Miller). 1869. Pen, wash, watercolour and gouache 35 x
44·3 cm. Signed bottom left: h.Daumier.
This picture was exhibited at the Salon of 1869 with another
watercolour, *Juges de la Cour d'Assise*, as yet unidentified.
There are three sketches which correspond to this drawing
(Boston, Museum of Fine Arts; Rotterdam, Museum
Boijmans-van Beuningen; Paris, Roger-Marx collection) and
another, slightly different finished version (Baltimore,
Walters Art Gallery), which brought the artist 200 francs
in 1877.

MEN, WOMEN AND CHILDREN:
THE STREETS OF PARIS

Daumier's paintings of women and children are among his most moving private subjects. Sometimes they seem to be more personal developments of earlier lithographs for *Le Charivari* (Plate 62), but they display a totally different interest on the part of the artist; his caricatures of independent women and female politicians (Plates 51–53) contrast with his paintings of laundresses or family scenes (Plates 54–58). And contemporary issues, such as the butchers' monopoly in Paris, made into amusing lithographs, formed the raw material of watercolours and oils (Plates 72 and 73). As a caricaturist Daumier was renowned for his range of expression and it was thought that he could dash off a sketch in the twinkling of an eye, getting a likeness or describing a situation with just a few lines. In fact he was an extremely painstaking draughtsman, interested in exploring all the visual possibilities of perhaps only a single figure, and beneath the surface of the finished pictures lies a complicated scaffolding of drawing. He experimented ceaselessly with types of figure, building up a select vocabulary of images which might be used in many paintings. He often repeated figures or treated the same scene from different points of view, and a theme which constantly recurs is that of the mother and child. They appear in paintings and sculpture; in studies of people oppressed by grief, poverty or toil (Plates 54 and 55), swindled by lawyers (Plates 22 and 24) or travelling peacefully in railway carriages (Plate 60). Usually these figures are set in urban surroundings, and here too Daumier displayed an enormous scope for experiment. For a series of humorous cartoons he designed scenes of Parisians who do not adapt to the country (Plate 61), but then he painted others who enjoy a day out and a good country meal (Plate 70). From these situations Daumier turned to studies of workmen in Paris (Plates 71–73), and then to the loiterers in the streets; the lonely, nocturnal figures who are still about when everyone else is asleep (Plates 74 and 75).

These subjects all link Daumier's paintings to those of contemporaries such as Manet (fig. 5) and anticipate the studies of everyday life made by van Gogh, Steinlen, Seurat and even Picasso. Daumier's 1878 exhibition included many such scenes which were evidently popular among collectors (Plates 63–65), but the majority, especially the pictures of women and children,

were still in the artist's possession at that time. There are about thirty-six paintings of women and children, including those in the interior of a railway carriage (Plate 60), and some thirteen of these works are portrayals of washerwomen, a theme which the artist himself evidently enjoyed painting. They are still regarded as classic nineteenth-century depictions of working-class figures.

50 *Portrait of a Girl* (*Portrait d'une jeune fille*)
VIENNA, Graphische Sammlung Albertina. Probably before 1830. Pencil, crayon and stump 28·6 x 22 cm. Signed and inscribed lower right: *A Jeanette* h.Daumier.
Thought to be Daumier's earliest drawing, it corresponds to one or two other highly modelled contemporary drawings of female heads. The identity of the sitter is not known.

51 *The Blue-Stockings* (*Les bas-bleus*), number seven
PARIS, Bibliothèque Nationale. *Le Charivari*, 26 February 1844. Lithograph 23·3 x 19 cm. Initialled bottom right: h.D. (H. & D. 691).
This caption reads: While Mummy composes baby decomposes! [La mère est dans le feu de la composition, l'enfant est dans l'eau de la baignoire.]
Le Charivari published forty prints entitled *The Blue-Stockings* from 30 January to 7 August 1844. Here Daumier used the overturned chair, which had already appeared in the *Rue Transnonain* lithograph (Plate 11), as a symbol of a child coming to grief. He was to use it again in a savage domestic dispute portrayed in one of ten prints published in *Le Charivari* in 1849 entitled *The Socialist Women* (Plate 52).

52 *The Socialist Women* (*Les femmes socialistes*), number seven
LONDON, British Museum, Department of Prints and
Drawings. *Le Charivari*, 23 May 1849.
Lithograph 24·4 x19·2 cm. Initialled left: h.D.
(H. & D. 1796).
This caption reads: '– You're my husband, Oh yes! – You
think you're the master . . . Let me tell you – I've got the
right to kick you out . . . Last night Jeanne Derouin [*sic*]
explained it all to me! . . . Go and explain yourself to her!
. . .' ['– Ah! Vous êtes mon mari, ah! Vous êtes le maître . . .
eh! bien moi, j'ai le droit de vous flanquer à la porte de chez
vous . . . Jeanne Deroin me l'a prouvé hier soir! . . . allez
vous expliquer avec elle! . . .']
On 22 March 1848 four delegates elected to the Committee
for the Rights of French Women presented themselves at
the Hôtel de Ville in Paris to put into the hands of the
provisional government a petition demanding votes and
equal rights for all men and women in France: One member
of this committee was Jeanne Deroin who ran two women's
newspapers, *La Politique des Femmes* and *L'Opinion des Femmes*,
and contributed to a third, *La Voix des Femmes*. All these
papers appeared in 1848 after the revolution, and were

mostly defunct within a year. Some of the articles in these
newspapers, written by Jeanne Deroin herself and by such
famous figures as Madame Sabatier (who was also a delegate
on the committee) and George Sand, advised women of
their rights within marriage, presumably the theme of
Daumier's lithograph. The policy of *Le Charivari* was to
attack women's movements as well as female professional
aspirations (Plate 51), women's newspapers and demands for
divorce (Plate 53). Daumier published ten plates entitled *The
Socialist Women* between 20 April and 9 June 1849. Captions
were written by the editors and Daumier himself evidently
drew required scenes without necessarily knowing the final
punch-line, as there are a further four unpublished plates in
this series for which no captions exist. The overturned chair
and the distressed child, which derive from *Rue Transnonain*
(Plate 11), by now became Daumier's symbols of domestic
disaster. An identical emblem of the overturned chair
appears both in *Shortly after the Marriage* and in *The Death of
the Countess*, the second and sixth of Hogarth's *Marriage à la
Mode* series, in which a young couple embark on a disastrous
marriage.

53 *The Divorcees* (*Les divorçeuses*), number one
PARIS, Bibliothèque Nationale. *Le Charivari*, 4 August 1848.
Lithograph 25 x 21 cm. Initialled bottom left: h.D.
(H. & D. 1580).

Caption: 'Citoyennes . . . It's rumoured that the divorce bill won't go through. Let's form a standing committee and declare a state of emergency!' ['Citoyennes . . . On fait courir le bruit que le divorce est sur le point de nous être refusé . . . Constituons-nous ici en permanence et déclarons que la patrie est en danger! . . .']

One month after the revolution, on 25 March 1848, posters appeared in Paris and Rouen which stated: 'We demand DIVORCE for women living in the Seine-Inférieure district, judicially separated from their husbands'. The demand was addressed to Frédéric Deschamps, the provisional government's commissioner for that part of France. Headlines in the principal newspaper representing the women's movement in Paris, *La Voix des Femmes*, printed the text of these posters verbatim. Perhaps it is no coincidence that Flaubert's novel *Madame Bovary* (1856) was set in Rouen and describes a disastrous marriage. According to *La Voix des Femmes*, the agitation for divorce was stronger in the provinces than in the capital, and the newspaper itself was not entirely in favour of a law of universal divorce on demand. *Le Charivari* also opposed the extremists and Daumier published six plates entitled *The Divorcees* between 4 August and 9 October 1848. This, the first of the series, shows a women's club. The woman speaker adopts a typical rabble-rousing gesture, one which Daumier later used for the figure who addresses the mob round Christ in *We Want Barabbas!* (Plate 19). In all his lithographs, especially those dealing with political issues, Daumier gave his figures specific gestures which are a type of visual language. Numerous sheet newspapers, sold on street corners during 1848, employed a similar language with crudely-drawn figures forming cartouches, marginal decorations and caricatures. One pink sheet entitled *Revue de Murailles* (dated 13 August 1848) printed burlesque adaptations of two of Daumier's famous lithographs: one, attacking Louis Philippe's Procureur du Roi, is a version of the *Rue Transnonain* (Plate 11) with the figures reduced to dolls; another caricatures this lithograph. The woman was changed into a male deputy who also declares a state of emergency in an effort to get people to vote for him.

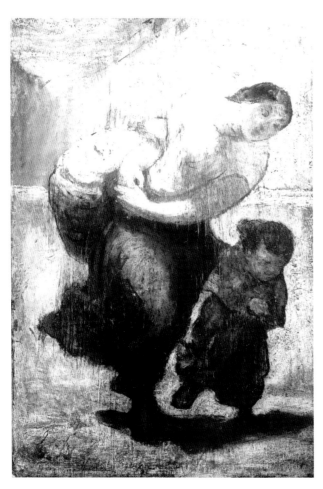

(above left)

54 *The Heavy Burden* (*Le fardeau*) or *The Washerwoman*
(*La laveuse*)

WINTERTHUR, private collection. c. 1852. Oil on panel 19·5
x 12·5 cm. Initialled bottom left: h.D.

'Who is the saddest and most saddening of widows: she
who trails with her a little child with which she cannot share
her meditation or she who is entirely alone?' These lines
from a late poem by Baudelaire, entitled *The Widows* and
published in 1861, summarize the mood of this image, an
archetypal study of oppression and grief that struck even
nineteenth-century spectators. Baudelaire's own editor,
Poulet-Malassis, recorded a visit he made to Daumier's
studio on the quai d'Anjou in January 1852 where he
probably saw this same picture: '. . . a washerwoman pulling
a small girl along in a high wind. A sketch of so sad a mood
that one might think the enormous heap of laundry under
her arm [is] on the way to the pawnbroker's.' Probably a
subject close to Daumier's own heart, this woman and child
spilled over into five paintings, a sculptured figure (Plate 55)

and some five known drawings. This tiny panel is probably
the earliest version, although another deeply shadowed
Washerwoman with a small child walking along the quai
d'Anjou (Washington, Phillips Collection) is dated as early as
1847. The figure also relates to many of Daumier's most
private works, those of fugitives and emigrants (Plates 83,
84 and 85), poor travellers (Plate 60), numerous
washerwomen (Plate 57) and impoverished widows (Plates
22 and 24).

(above right)

55 *The Heavy Burden* (*Le fardeau*)

BALTIMORE, Walters Art Gallery. c.1850s. Terracotta 35 cm.
high. Initialled on base of back: h.D.

This small model relates to the largest painted version of the
subject, destroyed in Paris during the Second World War.
Here the contours are loosely defined and the surface
textures roughly applied. Daumier apparently used a
combing tool and his fingers to achieve this effect.

(above)

56 *The Market* (*Le marché*) or *Women Emigrants* (*Femmes marchant pour l'exode*) or *Mother and Child* (*Femme tenant son enfant par le main*) or *Les fugitifs*

CAMBRIDGE (MASSACHUSETTS), Fogg Art Museum (bequest of Grenville L. Winthrop). Crayon, sanguine and wash with pen and ink over charcoal 36·5 x 30 cm. Unsigned.

As the many titles suggest, confusion exists as to the real subject of this drawing. When it was first exhibited at Durand-Ruel's gallery in 1878 it had the title of *Le marché*. Subsequently it has been associated with Daumier's obsessive studies of emigrants, refugees and fugitives (Plates 83-85). The flowing lines of the drawing give the figures an elegance and, perhaps intentionally, this woman forms a striking contrast with the subject of *The Heavy Burden* (Plate 54). The work may belong to the series of market scenes which Daumier sketched in the 1860s (Plates 72 and 73) and stylistically it resembles *The Water-carrier* (Plate 71).

(overleaf)

57 *The Washerwoman* (*La laveuse*) or *A Washerwoman of the quai d'Anjou* (*Une laveuse du quai d'Anjou*) or *The Laundress* (*La blanchisseuse*)

PARIS, Musée du Louvre. 1863–64. Oil on panel 49 x 33 cm. Initialled bottom right: h.D.

This is probably the last version of three almost identical paintings. The other two are at the Albright-Knox Gallery, Buffalo, and the Metropolitan Museum of Art, New York. The Buffalo painting appeared at the Salon of 1861 and the Metropolitan work in 1878 when Duranty described the background: 'The water of the river has the blue of a precious stone . . .' This work was exhibited for the first time in Paris in 1901. It is darker than the earlier pictures and here the buildings are more sharply defined; the subject itself obviously relates to that of *The Heavy Burden* (Plate 54).

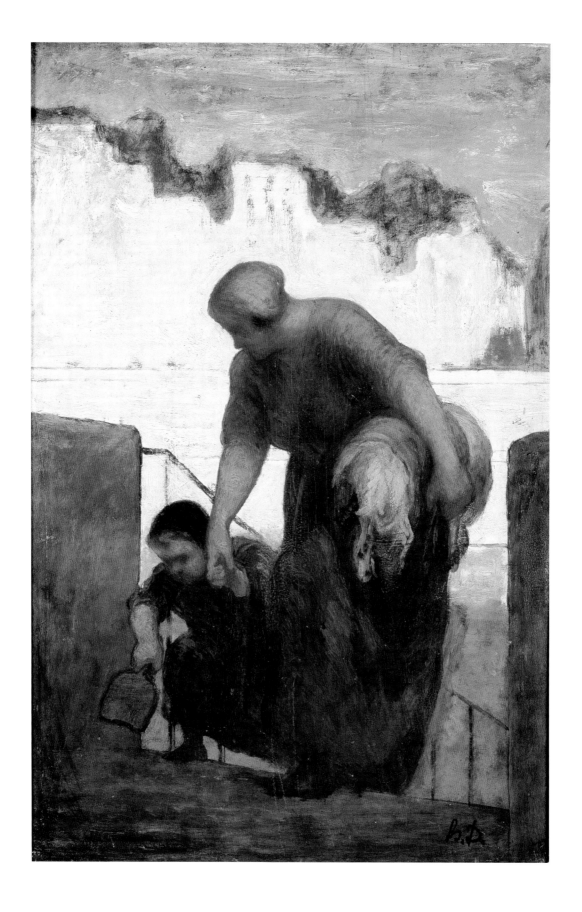

(above)

58 *Family Scene (Scène de famille)*

CHICAGO, Art Institute of Chicago (gift of Joseph and
Helen Regenstein). Pen, ink and wash 21·6 x 20·1 cm.
Initialled bottom right: h.D.

Probably another fairly late drawing, its subject may have
been influenced by some of Millet's family scenes. The
repeated lines of the drawing and the washed-in contours
recall the style of *The Counsel for the Defence* (Plate 28).

(overleaf)

59 *The Print Collector (L'amateur d'estampes)*

PHILADELPHIA, Philadelphia Museum of Art (W. P.
Wilstach collection). c. 1860. Oil on panel 35 x 26 cm.
Initialled bottom left: h.D.

Two slightly different versions (Paris, Musée du Petit Palais;
and New Orleans, private collection) and two preparatory
sketches (Paris, Roger-Marx collection; and Canada, private
collection) demonstrate the care Daumier took to complete
the composition. This panel may well be the penultimate

attempt in oil, although the brushwork is much freer than
that of the finished painting in the Musée du Petit Palais.
Daumier inscribed thick ridges all over the surface of this
work, out of which the forms emerge, a technique which
anticipates the sensitive, linear painting developed by Edvard
Munch (fig. 6) at the end of the nineteenth century. Here,
Daumier's figure wears a costume similar to that of *Ratapoil*
(Plate 13), unlike the picture in the Musée du Petit Palais, in
which the collector's long, trailing coat was tidied up into a
short jacket, muffler and less battered hat. The Paris version
was exhibited in 1878, but this sketch was not shown
publicly until 1910. It is probably one of Daumier's most
experimental paintings and a masterpiece in its own right.
Evidently popular, these subjects of minor collectors
looking through portfolios of prints were described by
Duranty in 1878 as, 'Marvels of airy luminosity which
blossom into grey, blue or green tones'. Although Duranty
could not have known this particular work, his comment
aptly summarizes its colouristic subtleties.

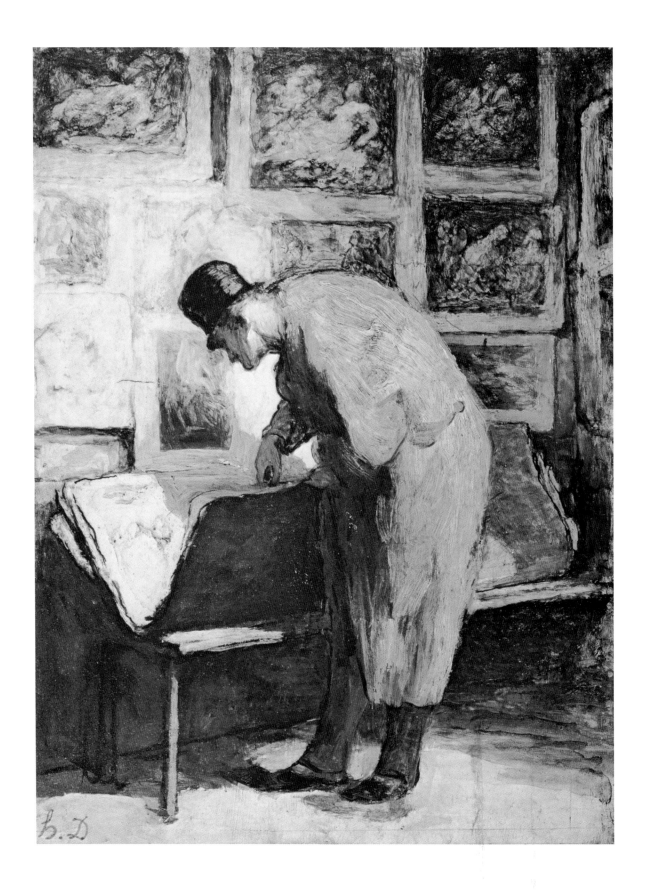

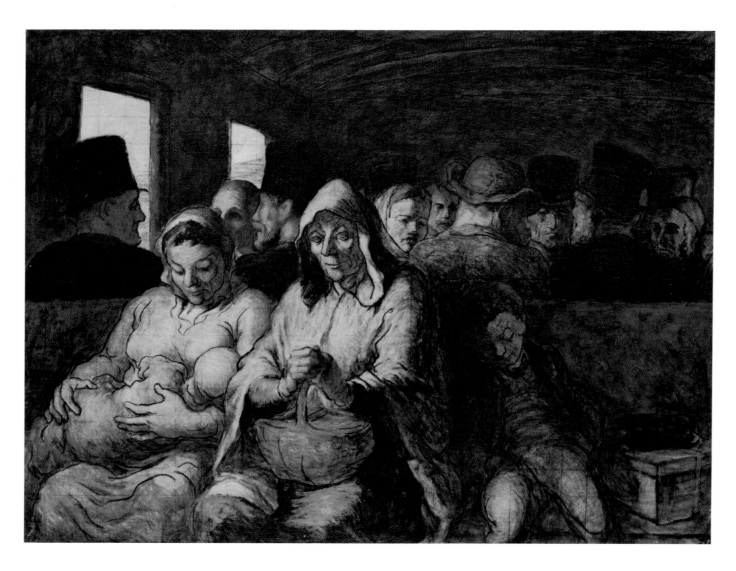

(above)

60 *The Third-class Railway Carriage* (*Un wagon de troisième classe*)
(see page 89)

NEW YORK, Metropolitan Museum of Art (bequest of Mrs
H. O. Havemeyer). 1863–65. Oil on canvas 65·4 x 90·2 cm.
Unsigned.

Daumier's complicated construction of this scene, probably
carried out in the mid-1860s, reveals the efforts he made to
extract the fullest possibilities out of a popular subject. This
painting was enlarged from a tracing taken from a
watercolour (Baltimore, Maryland Institute), made for H.
Walters (see Plates 78 and 79). Daumier achieved the
transfer of the image by squaring up the canvas, and these
lines are visible through the paint. The combination of
another tracing made from this painting and an inverse

tracing resulted in the final version (Ottawa, National
Gallery of Canada). Exhibited in Paris in 1878, the Ottawa
picture fetched 46,000 francs at the Doria sale in 1899. This
version was exhibited in Paris in 1888 and H. O. Havemeyer
obtained it through Durand-Ruel. It shows a number of
glazes and black lines moulding the figures, and
panchromatic and infra-red photographs have shown how
frequently Daumier changed his mind, altering and
correcting the images which he had already worked out from
the Baltimore watercolour. The figures grew gradually into
their final form as Daumier used layers of paint in a
technique almost akin to watercolour, which gives the
figures their monumentality. This work is probably one of
the artist's finest masterpieces and it has inspired numerous
copies and forgeries.

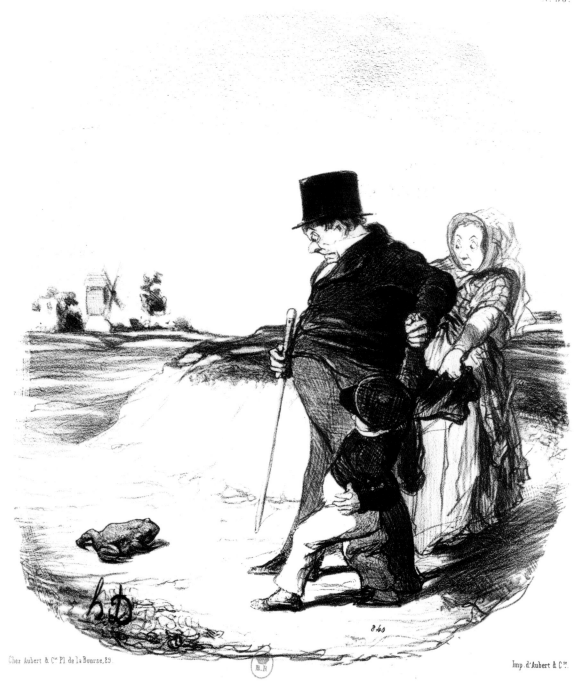

61 *Pastorales*, number thirty-six: *Face to Face with a Frightful Creature* (*Une terrible rencontre*)

PARIS, Bibliothèque Nationale. *Le Charivari*, 7 December 1845. Lithograph 26·2 x 22·6 cm. Initialled bottom left: h.D.

(H. & D. 2251).

The series of fifty prints entitled *Pastorales* appeared in *Le Charivari* between 1845 and 1846.

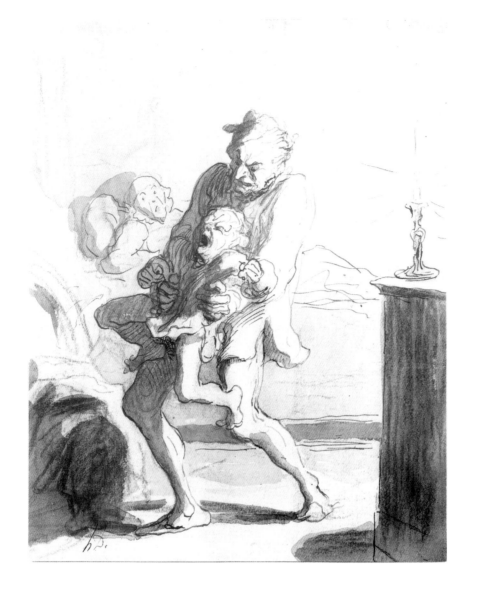

62 *Domestic Scene* (*Scène de ménage*) or *Fatherly Correction*
(*La correction paternelle*)
CHICAGO, Art Institute of Chicago (Arthur Heun fund).
1857–58. Pen and wash 25·3 x 20 cm.
Initialled bottom left: h.D.
The figure of the woman and the lighting are particularly
reminiscent of drawings by Rembrandt, whose work
Daumier studied with renewed interest in the late 1850s
after several new masterpieces by the Dutch artist were
acquired by Napoleon III (Plate 73 and fig. 7). This drawing
may have been executed as part of a series of contemporary
scenes which Daumier produced for dealers in the early
1860s (Plates 77 and 78). Exhibited at Durand-Ruel's in
1878, the drawing re-explores a popular theme from

Daumier's earlier lithographs. In *Le Charivari*, from
December 1846 to June 1849, the artist published twenty-
three lithographs entitled *Les Papas* which depicted the trials
and pleasures of fatherhood. One plate, *A Disturbed Night*,
dated 30 June 1847, is a less savage version of this drawing;
in the lithograph the father is younger, the mother less
downtrodden. But the caption could well be used here: 'Yell
and scream you little brat! . . . How I you little swine . . .
Scream your head off and have done with it! . . . To think
I've not had a wink of sleep because of this kid!! To hell
with children! Damned if I'll have any more . . .!' ['Crie donc
mâtin! . . . Geuele donc! . . . égosilletoi donc et que ça finesse
. . . ne pas fermer l'oeil pour un méchant moutard!! le diable
emporte les enfants! je n'en veux plus . . .']

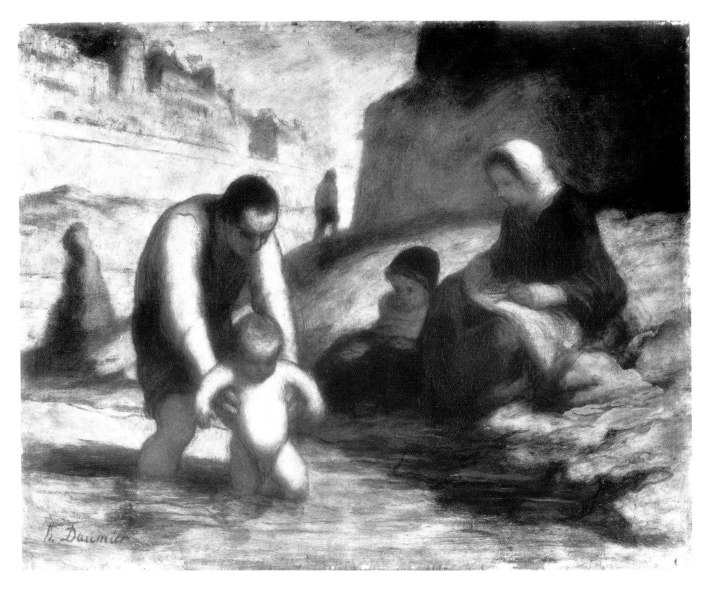

63 *The First Bathe* (*Le premier bain*)
DETROIT, Detroit Institute of Arts (bequest of Robert H. Tannahill). c. 1853 or after c. 1858. Oil on panel 23·5 x 33·5 cm. Signed bottom left: h.Daumier.
One of Daumier's most popular works in his own lifetime, this design has inspired numerous copies and forgeries. Two versions by Daumier, this and a canvas in the Reinhart Collection, Winterthur, were shown at the artist's one-man exhibition in Paris in 1878. The Winterthur painting shows the man holding the child with his hand overlapping its arm and the scene, set beneath the arch of a bridge, includes

more figures and children at play. It was entitled *Les enfants du bain* at the exhibition. The difficulty of dating these works is increased by the similarity between Daumier's first idea, shown in the preliminary sketch (Plate 64), and a drawing by Millet (fig. 13) dated 1855–57. Daumier probably first met Millet in the late 1840s and there are several instances of his dependence on the younger artist's work. Millet's most successful compositions included peasant family scenes which Daumier here transferred into a study of urban family life.

64 *Woman Guiding her Child* (*Femme guidant son enfant*)
LONDON, British Museum, Department of Prints and
Drawings, c. 1852–55 or after c. 1858. Charcoal and stump
on blue paper 29·9 x 20 cm. Unsigned.
This is a drawing for *The First Bathe* (Plate 63). Here the
resemblance to a drawing by Millet (fig. 13) is extremely
close. Daumier's first plan for the design shows a woman
and a child with its arms upraised. In all known versions of
the painting, Daumier changed the central figure into a man.

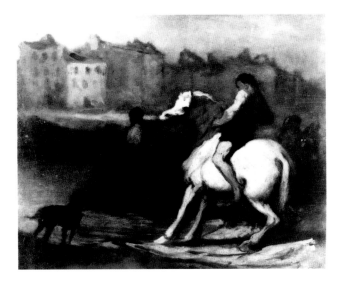

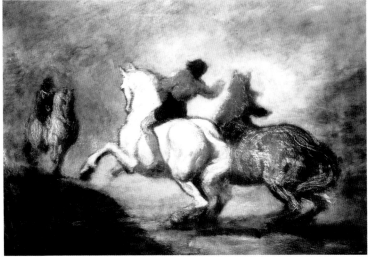

(above left)

65 *The Watering-Place* (*L'abreuvoir*) or *By the Seine* (*Bords de la Seine*)

CARDIFF, National Museum and Gallery. c. mid-1850s. Oil on panel 44·5 x 54·6 cm.

Initialled bottom right: h.D.

Exhibited in 1878 under the first title, when it was still in Daumier's studio, this painting was bought by the artist's first biographer Arsène Alexandre. The houses in the background recall the view across the Seine in *The Nightstrollers* (Plate 75) and here, too, the colour has darkened.

(above right)

66 *Riders* (*Les cavaliers*) or *Horses at the Watering-Place* (*Chevaux à l'abreuvoir*) or *Horses and Riders* (*Chevaux et cavaliers*)

BOSTON, Museum of Fine Arts (Arthur Gordon Tompkins residuary fund). c. 1855. Oil on canvas 60·6 x 85 cm.

Initialled bottom left: h.D.

There are two other paintings by Daumier in which the central rider on the rearing horse appears (formerly collection of Jules Braut, whereabouts now unknown; and New York, private collection). There are also a number of related drawings. One of these (formerly Vollard and Carstairs Gallery, whereabouts now unknown) is probably a copy of the Parthenon frieze, which suggests that Daumier's distinctive, beautifully designed riders were inspired by the flowing patterns of classical horsemen. Sold in 1901 for 1100 francs, this painting fetched 4800 francs five years later.

67 *Head of a Man* (*Tête d'homme*)

CARDIFF, National Museum and Gallery. Oil on canvas 26 x 34 cm. Initialled bottom right: h.D.

Acquired by the Misses Davies in February 1914 through Wallis and Son, this head was copied by Daumier from one of his own works *The Family on the Barricades* (Prague, Národni Galerie). Thought to be an early work showing an incident from the 1848 revolution, *The Family on the Barricades* is now known to have been repainted and 'finished' by another hand and only this head of the central figure remains, probably painted by Daumier some time after the original work. Here the underpainting shows through, reddish brown, as in *Lunch in the Country* (Plate 70); the background is a deep blue. Daumier's brushwork is rough and free and there are two noticeable *pentimenti*, round the nose and on the left shoulder. There is a preparatory drawing for this head in a private collection in Paris.

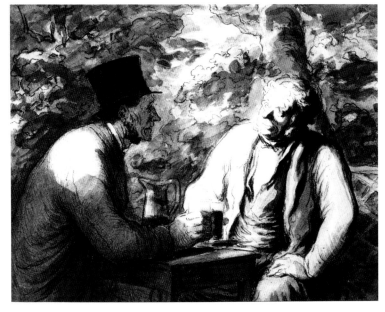

(above left)
68 *Two Men (Deux hommes)*
LONDON, Victoria and Albert Museum. Pen and
watercolour 25 x 18·5 cm. Unsigned.
In this drawing Daumier used watercolour as if it was oil
paint and brushed thick blocks over pen lines to construct
the figures.

(above right)
69 *The Good Friends (Les bons amis)*
BALTIMORE, Baltimore Museum of Art (George A. Lucas
collection, on loan from the Maryland Institute). Pen and
white chalk over pencil and washed watercolour and white
gouache 22·8 x 30 cm. Signed bottom right: h.Daumier.
This is another drawing which G. A. Lucas bought from
Daumier, probably in the early 1860s.
The pose of the right-hand figure, with the hand on the
knee, is strikingly similar to that of Ingres's *M. Bertin* (Paris,
Musée du Louvre).

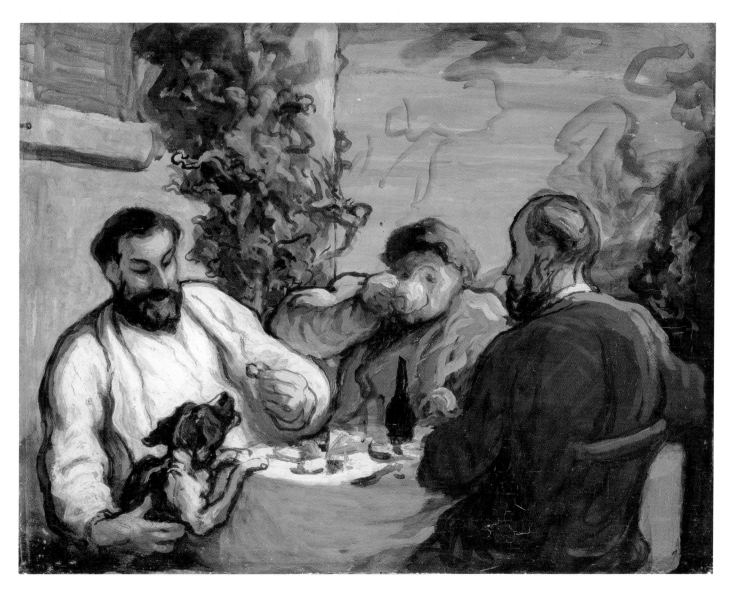

70 *Lunch in the Country* (*Un déjeuner à la campagne*) or *The End of the Meal* (*Fin d'un déjeuner*)
CARDIFF, National Museum and Gallery. c. 1860–68.
Oil on panel 25·5 x 33·5 cm. Unsigned.
Exhibited in Paris at Daumier's one-man exhibition of 1878 under its first title, this picture was also included in an exhibition at the Ecole des Beaux-Arts in 1901 as *Fin d'un déjeuner*. Acquired by Gwendoline Davies through Bernheim in 1917, the work displays Daumier's intensified panel-painting technique developed from earlier panels such as *The Nightstrollers* (Plate 75). Thick layers of paint have been used to construct the background but, unlike the smooth masses of the earlier work, these layers are broken up into sections of horizontal and vertical brushstrokes. On top of these underlying areas lie the striations which delineate objects and figures. They also seem to be carefully placed, although the details are loosely handled; it is possible to see that there is wine, salad, bread and cheese on the table, that the central man is drinking coffee and that the man on the left is offering his dog a piece of bread on which butter or cheese is thickly spread. The colours are comparatively bright and there is a lot of pinkish-brown underpainting in the sky. A preparatory sketch for this painting is in Winterthur (Reinhart Collection).

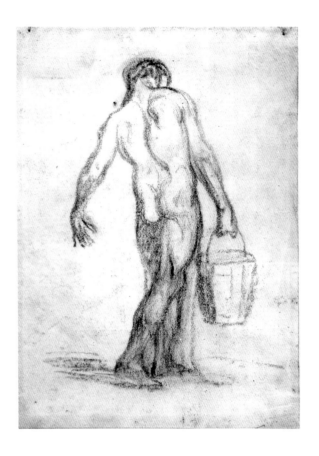

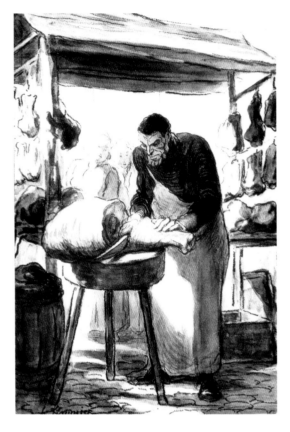

(above left)

71 *The Water-carrier (Le porteur d'eau)*
LONDON, British Museum, Department of Prints and
Drawings. c. late 1850s. Charcoal on light-blue paper 27·9 x
20 cm. Unsigned.
This is a preparatory drawing for an oil painting of even
smaller dimensions (26 x 16 cm.) in the Barnes Foundation,
Merion, Pennsylvania. On the verso is *Woman Guiding her
Child* (Plate 64), a preliminary drawing for *The First Bathe*
(Plate 63).

(above right)

72 *The Charcutier (Le charcutier* or *Le boucher de Montmartre)*
WINTERTHUR, Oskar Reinhart Collection 'Am Römerholz'.
c. 1860. Crayon, pen, ink, wash and watercolour 27 x 19 cm.
Signed bottom left: h.Daumier.
In Paris, most *charcutiers* were foreigners selling mainly pork
in markets, as depicted here, or later in the nineteenth
century, in expensive and exotically decorated shops. This is
another watercolour from the series showing men at work in
Paris (see Plate 71).

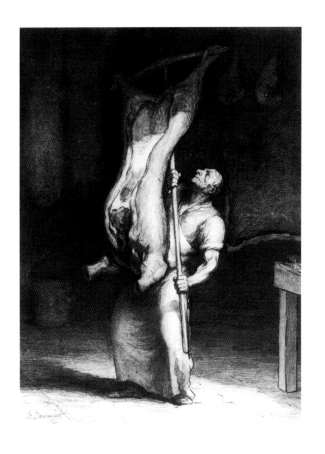

(above left)

73 *The Butcher* (*Le boucher*)

CAMBRIDGE (MASSACHUSETTS), Fogg Art Museum
(bequest of Grenville L. Winthrop). c. 1860. Pen, ink and
watercolour 32·8 x 22·5 cm. Signed bottom left: h.Daumier.
Up to 1848 there was an association of 400 butchers in
Paris. Five abattoirs were situated near markets in places like
Montmartre and Saint-Philippe-du-Roule. After an epidemic
of cholera in 1832 the abattoirs were reorganized, and by
November 1857 the butchers' monopoly had been abolished
and their privileges considerably reduced. Daumier
caricatured the butchers' protests in a famous lithograph in
Le Charivari of November 1857, a print which he also made
into an oil painting (Kintonah, New York, Askin collection).
This drawing is one of four finished watercolours, three of
butchers and one of a *charcutier* (Plate 72); it probably relates
to a series of works Daumier made depicting workmen in
the streets of Paris. In 1857 Napoleon III acquired for the
Musée du Louvre Rembrandt's painting, *Carcase in a Butcher's
Shop* (fig. 7), which Daumier obviously transcribed in
this work.

(above right)

74 *Vulgarities* (Vulgarités), *number two*

LONDON, British Museum, Department of Prints and
Drawings. Le Charivari, 12 March 1841.
Lithograph 24·1 x 16·8 cm. Initialled bottom left: h.D.
(H. & D. 2752).
This caption reads: 'Cor! These bloody boots, they've
soaked up more than me! . . . and they're still at it! . . .'
['Cré nom! Elles sont plus heureuses que leur maître, ces
gueuses de bottes! . . . elles boivent! . . .']
Daumier designed ten Vulgarités plates for Le Charivari,
published between 6 February 1841 and 28 May 1842. There
are three known states of this print, the last one being sold
at Aubert's shop as part of the complete set. Manet may well
have seen this particular design years later when he was
preparing his famous painting *The Absinthe Drinker* (fig. 5)
for the Salon of 1859.

75 *The Nightstrollers* (Les noctambules) or *A Paris Street* (Dans une rue de Paris) or *Moonlight* (Effet de clair de lune) CARDIFF, National Museum and Gallery. c. 1847–60. Oil on panel 28 x 18·7 cm. Initialled bottom left in red: h.D. Possessing a slightly convex surface, this panel shows many layers of paint smoothed over the background, from which Daumier's initials and the lemon-coloured impasto of the moon emerge as the only true colours. The rest of the picture is almost monochromatic although the tones have probably darkened. Generally dated in the late 1840s, the work may have been finished much later, as Daumier seems to have overpainted it several times, erasing a third figure whose outline can still be faintly seen to the left of the fat man in the top hat. The black lines which describe the men's faces, the central parapet and the distant buildings were probably added as the final touches. Exhibited in Paris in 1888, at the Caricature Exhibition at the Ecole des Beaux-Arts, Daumier's painting is an evocative work with an unusually gentle mood. It reflects the imagery of several late poems by Baudelaire, notably *Evening Twilight*. Alexandre Privat d'Anglemont who, like Daumier and Baudelaire, also lived for a time on the Ile Saint-Louis, described similar scenes in his book Paris inconnue, set in this same, rather remote area of Paris which Daumier may have portrayed here.

RAILWAYS AND OMNIBUSES

In 1863 Daumier and his wife began to spend summers regularly in Valmondois, the village in the valley of the Oise where Daumier died in 1879. It was probably at this time that he made a series of paintings and drawings on the theme of railways, a subject he had already treated in lithographs as early as 1843 (Plate 76). By the 1860s most of the main line stations in Paris were built, or in the process of completion. These stations organized their passengers on a strictly hierarchical system, which obviously fascinated Daumier. His studies concentrate on the divisions between types of passengers, in both waiting rooms and carriages. First-, second- and third-class passengers were separated, even before boarding the train. They were kept in their appropriate waiting rooms until the moment for starting. Daumier observed all stages of the journey, even the wild dash down the platform to catch the train after the passengers' release from the waiting rooms.

Presumably Daumier himself travelled by railway to the country on his summer vacations, as he particularly showed an interest in portraying the third-class passengers (Plates 60 and 80). Third-class carriages were attached to local trains and not to the mail or express trains for long journeys, which consisted of first- and second-class only. There are two pictures of a first-class carriage (Plate 78), only one of second-class (Plate 79) and several third-class designs (Plates 60 and 80) from this particular series. Significantly some of the works appear to have been made by Daumier for a foreign market. The first- and second-class carriages (Plates 78 and 79) were produced as a pair for 200 francs in 1864 for the American G. A. Lucas, a retired railway engineer, who bought works on behalf of American collectors. In these the weather is important: the first-class carriage has the sun shining through the window, the second-class is a winter scene. Both show long journeys and the effect on different types of passenger. The third-class carriage is, by contrast, an open interior and occasionally the characters who appear in the third-class waiting room are followed by the artist into the carriage (Plates 80 and 81). The only waiting scene inconsistent with urban railways is *Waiting at the Station* (Plate 82). In this the figures are evidently waiting at a country station which suggests that Daumier painted it during or after one of his summers at Valmondois, when he would have travelled probably on the Paris-Argenteuil line, leaving from the Gare Saint-Lazare (fig. 16).

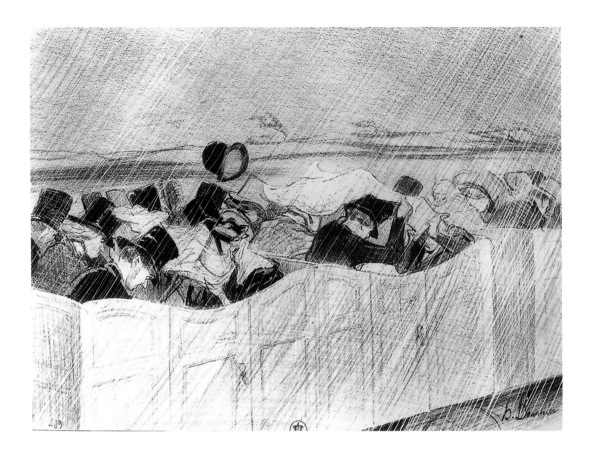

76 *The Railways (Les chemins de fer)*, number six: *A Pleasant Journey from Paris to Orléans (Un voyage d'agrément de Paris à Orléans)*

PARIS, Bibliothèque Nationale. *Le Charivari*, 7 July 1843. Lithograph 26 x 19·3 cm. Signed bottom right: h.Daumier. This caption reads: 'Bloody Hell it's pouring! . . . You won't catch me in one of these cattle trucks again! . . .' ['Saperlotte quelle trempée! . . . il ne m'arrivera plus de prendre un wagon non couvert quand le ciel l'est beaucoup trop! . . .'] Despite a passionate plea from Lamartine in 1838 that French railways should be state-owned, a law passed on 7 July 1838 granted concessions to private companies to build three main lines from Paris to Le Havre, Orléans and Strasbourg. By 1839 the cost of constructing these lines far exceeded original estimates and the companies were threatened with bankruptcy. The Paris-Orléans Company obtained state aid in the form of a forty-year guarantee to investors at interest of four percent, granted on 15 July 1840. Another bill of 1842 formed a railway co-operative between the government and the company and the Paris-Orléans line was the first major railway line to open. On 2 May 1843 the inaugural journey took place. Predictably it rained the whole way and the passengers in the uncovered third-class coaches were soaked. Another of Daumier's railway lithographs shows the third-class passengers being catapulted out of their carriages because of a sudden stop, and the trials of those in the third-class were to give Daumier material for some of his most important paintings (Plates 60, 80 and 81).

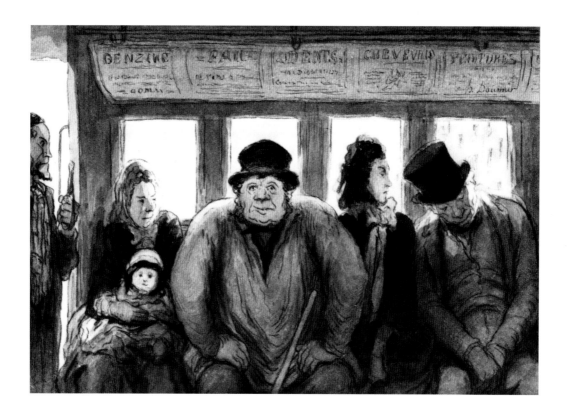

77 *Interior of an Omnibus* (*Intérieur d'un omnibus*)
BALTIMORE, Walters Art Gallery (on loan from the
Maryland Institute). 1864. Crayon and watercolour
21·2 x 30·2 cm. Signed top right on advertisement:
Peintures . . . h.Daumier.

Executed for the American collector and agent G.A. Lucas,
a retired railway engineer, this watercolour together with the
first- and second-class carriage interiors (Plates 78 and 79) is
among the few works by Daumier which can be accurately
dated. Lucas's diary records the whole transaction: on 19
March 1864 he returned a drawing to Daumier to be
finished, and nearly a month later, on 13 April, Daumier told
Lucas that he could collect this work. A few days later Lucas
ordered the watercolours of the first- and second-class
carriages for 200 francs. He did not record the sum paid for
this drawing and Lucas was not buying for his own
collection but for another American collector, the railway
magnate William Walters. Here the signature is significant.
Although Daumier had returned to work for *Le Charivari* in

the previous year, he was still desperately trying to build up
his commercial practice as a painter and he actually
advertises his skills on the billboards of the omnibus.
Through Lucas many people bought Daumiers: Lucas
himself owned two (Plates 25 and 69) and collected editions
of the lithographs, but all these collectors seem to have
wanted works which resembled Daumier's newspaper
lampoons. Accordingly it is not really surprising to find that
this subject had already appeared in a comic lithograph for
Le Boulevard in 1862, or that it had been used in January of
the same year for a woodblock reproduction which appeared
in *Le Monde Illustré*. Both the depictions of the second- and
third-class carriages evolved from similar backgrounds. This
scene, like the original lithograph, shows the famous line 'E',
which ran from the Madeleine to the Bastille, a route starred
in English and American guide-books to Paris published in
the 1860s as being of particular interest to tourists. There is
a preliminary drawing for this watercolour in a private
collection in Paris.

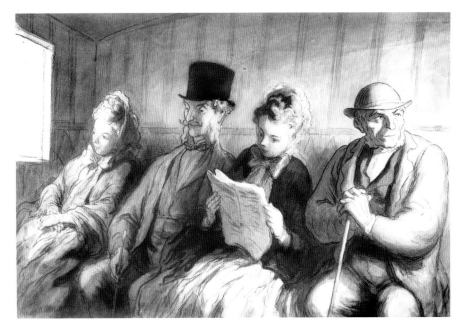

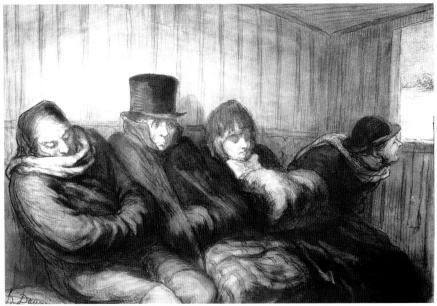

(top)

78 *Interior of a First-class Railway Carriage*
(*Intérieur d'un wagon de première classe*)
BALTIMORE, Walters Art Gallery (on loan from the
Maryland Institute). 1864. Crayon and watercolour 20·5 x
30 cm. Signed bottom left: h.Daumier.
According to Lucas's diary (see Plate 77), this drawing and
its companion (Plate 79) took the artist two months to
make. There is a preliminary, unsigned drawing in a New
York private collection.

(bottom)

79 *Interior of a Second-class Railway Carriage*
(*Intérieur d'un wagon de deuxième classe*)
BALTIMORE, Walters Art Gallery (on loan from the
Maryland Institute). 1864. Crayon and watercolour 20·5 ¥
30·1 cm. Signed bottom left: h.Daumier.
A slightly different woodcut reproduction appeared in *Le
Monde Illustré* in January 1862. There are several painted
imitations and forgeries of this work, but apparently no
preliminary drawing.

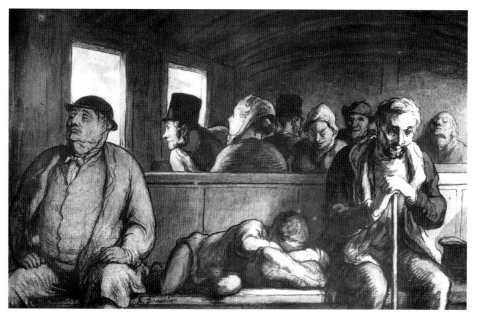
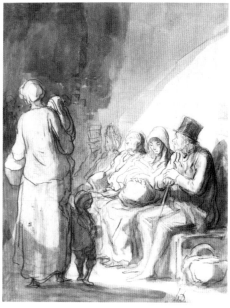

80 *A Third-class Railway Carriage* (*Un wagon de troisième classe*)
WINTERTHUR, Oskar Reinhart Collection 'Am Römerholz'.
c. 1860s. Crayon, pen and ink and watercolour heightened
with white 23 x 33 cm. Signed on bottom edge of seat:
h.Daumier.
Exhibited in Paris at the Exposition Internationale
Universelle, this work may well be contemporaneous with its
more famous namesake (Plate 60). There is one preliminary
drawing (Los Angeles, Norton Simon Collection) and an oil
copy on panel in France.

81 *The Third-class Waiting Room* (*La salle d'attente de troisième
classe*) or *A Waiting Room* (*Une salle d'attente*)
WINTERTHUR, Oskar Reinhart Collection 'Am Römerholz'.
c. 1860s. Crayon and watercolour 26·5 x 21 cm. Initialled
bottom right: h.D.
The figures in this watercolour correspond to some of those
in the two studies of the *Third-class Railway Carriage* (Plates
60 and 80). Shown at Daumier's exhibition in 1878, the work
was exhibited again in Paris in 1901.

113

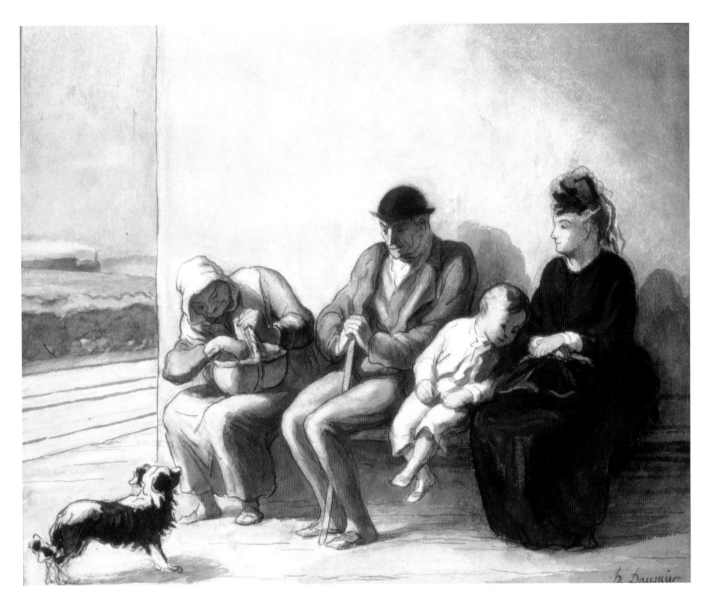

82 *Waiting at the Station* (*L'attente à la gare*)
LONDON, Victoria and Albert Museum. c. late 1860s.
Crayon and watercolour with some pen and ink 28 x 34 cm.
Signed bottom right: h.Daumier.
Exhibited in 1878, *Waiting at the Station* may be one of the
last which Daumier made in the series. A preliminary

drawing in a New Jersey private collection shows a
completely different woman, older and hatless. In this work
she became a fashionable figure, resembling some of the
female portraits made by Manet in the late 1860s and early
1870s.

FUGITIVES AND EMIGRANTS

Daumier made two bas-reliefs (Plate 84), some five or six paintings (Plate 85) and several drawings (Plate 86) depicting long lines of people, apparently dispossessed, moving against a stormy background or fleeing from some undefined disaster. The exact meaning of this subject has never been explained, but all Daumier's images in this series observe certain pictorial conventions which can also be found in the pictures by earlier painters who represented the Deluge. The refugees or fugitives in Daumier's pictures are family groups represented by women and children, elderly men and men in the prime of life. Sometimes they carry baggage or ride horses, usually they are nude or wear classical drapery. Daumier surrounded the figures with clouds of smoke and a pall hangs over the colours, making the light dramatic. In one drawing buildings fall (Plate 86), suggesting an earthquake or volcano; in two paintings the figures appear to flee from a fire (Plates 83 and 85); a landscape sketch, connected with this theme, also shows how Daumier designed the terrible darkness of the cataclysmic storm (Paris, Roger-Marx collection) again linking his design of the mysterious inundation to previous works.

In France and England at the beginning of the nineteenth century, pictures of families caught in the biblical Deluge or some natural or divine chaos were very popular. Examples are many, the most memorable made by artists as diverse as Girodet, Regnault, Danloux, Turner and John Martin. In 1829 and 1834 John Martin won gold medals at the French Salon with *Balshazzar's Feast* and *The Deluge* respectively, and *The Deluge* was exhibited again in Paris in 1863. Martin was famous for painted theatrical effects. In his pictures vast, fantastic architecture and dramatic vistas of typhoons and falling mountains dwarf the desperate human figures. In France both poets and painters seized on his exciting images and often used them in their own work, giving them a new vitality. Victor Hugo and Gérard de Nerval are known to have admired John Martin, and Hugo's poem *Fire in the Sky* in *Les orientales* of 1829 contains the passage: 'Great palaces crumble, a thousand chariots flee, their axle trees jostling and the milling crowds find a river of fire in every street'. Daumier's friend Michelet also admired John Martin, collecting engravings after the most

famous pictures, and he too elaborated on the excitement of the English artist's scenes: 'Oriental cataclysms and a huge destruction of people, the desolation . . .' Whether Daumier knew Martin's pictures or not, he could not have failed to notice how the theme haunted the paintings sent to French Salons. Delacroix's *Death of Sardanapalus* of 1827 was perhaps the most notoriously violent work to emerge from this fascination with disaster, and Decamps's *Defeat of the Cimbri* of 1834 put long lines of struggling figures against the background of a stormy battlefield. Daumier's fugitives and refugees share the pictorial conventions of the nineteenth-century 'Deluge' picture but they rarely show the cataclysm actually taking place, and his interest may have been aroused by somewhat different prototypes.

In 1843 a painting by Corot entitled *The Destruction of Sodom* (fig. 9) was refused at the Salon. Accepted in 1844, this work was exhibited again at the Salon of 1857 after Corot had cut it down and virtually repainted it. Corot's influence was important for Daumier in the 1850s and 1860s and Corot's figures fleeing from Sodom in their flowing robes with a lurid, streaky sky behind them, recall particularly Daumier's version of *The Fugitives* in Winterthur (Plate 83). This would probably date Daumier's picture in the late 1850s. Another reason for this date is the craze there was in France for Edward Bulwer-Lytton's novel *The Last Days of Pompeii*. First published in 1834 it was translated into French by the late 1830s, but the most important French editions appeared in the 1850s and 1860s. At the end of the novel a vivid description of the fugitives fleeing from Pompeii describes the sea, the streaky sky, the fire and the black clouds which throw the refugees into lurid relief. It is not known if Daumier read the story but his pictures and sculpture (Plate 84) have stylistic connotations with Roman bas-reliefs. Set in narrow spaces, the figures line up and overlap each other in a manner which recalls the figures on Trajan's Column, casts of which Daumier kept in his studio. Both Trajan's Column and the column of Marcus Aurelius show fugitives dispossessed by Roman armies. In Daumier's transcriptions the people have a universal, anonymous quality and perhaps it is not too difficult to relate them to the weary travellers in *The Third-class Railway Carriage* (Plate 60) or the lonely riders, Don Quixote and Sancho Panza (Plates 87–92).

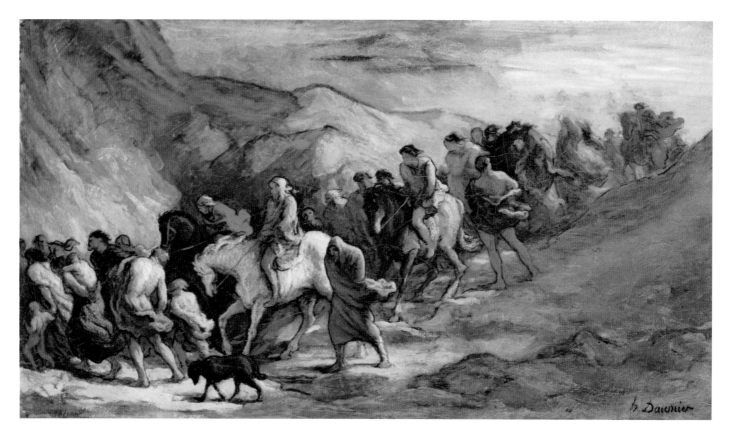

83 *The Fugitives* (*Les fugitifs*)
WINTERTHUR, Oskar Reinhart Collection 'Am Römerholz'.
c. late 1850s or 1860. Paper laid on canvas 38·5 x 68·5 cm.
Signed bottom left: h.Daumier.

Exhibited in Paris in 1900, this is the most finished version
of the subject and it is this painting which most recalls *The
Destruction of Sodom* by Corot (fig. 9).

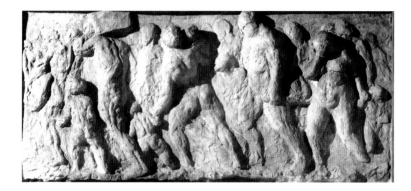

84 *The Emigrants*
PARIS, Geoffroy-Dechaume collection. Original plaster
28 x 66 cm.
This sculptured relief probably anticipates the painted
versions (Plates 85 and 83) because a lithograph by
Daumier, published in *Le Charivari* in 1850, shows a
sculptor's studio. On the wall is a similar relief, although the
figures appear to be draped. When Poulet-Malassis visited
Daumier's studio in 1852 (see Plate 54) he noticed a figure
relief, although it might have been a work by Préault (see fig.
3). There is a preliminary drawing in Paris (Roger-Marx
collection). Another drawing of a nude woman with two
children (Manchester, Whitworth Art Gallery) may be a
study for the central figure, in reverse. Like all Daumier's
pieces of sculpture, this relief was originally made in clay.

Geoffroy-Dechaume made two plaster casts, of which, it is
generally thought, this one is the earliest, although it is
usually referred to as 'the second version'. Both may have
been exhibited in 1878. Some three bronze editions were
made from this version, and technical evidence suggests that
it has probably suffered two kinds of damage: the first when
Daumier himself was working on it and allowed the clay to
dry, causing details to break off in the casting, and years
later, possibly in the early part of this century, when the cast
was broken. The so-called 'first' plaster version of this
design was acquired from the Geoffroy-Dechaume
collection in 1960 by the Musée du Louvre. It is smaller,
more evenly modelled and the technique has been attributed
to a later period in Daumier's career.

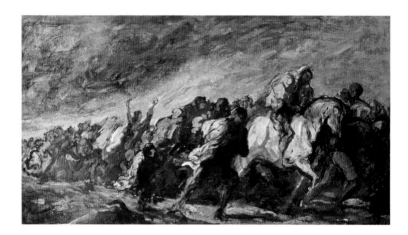

85 *The Fugitives (Les fugitifs)* or *The Emigrants* or *Emigration*
MINNEAPOLIS, Minneapolis Institute of Arts (Ethel
Morrison Van Derlip fund). c. late 1860s.
Oil on linen 38·7 x 68·5 cm. Initialled bottom right: h.D.
Exhibited in 1878 under the title *The Emigrants*, this picture
first belonged to the painter Daubigny. There is a

preparatory drawing in chalk (Paris, Roger-Marx collection)
and the dimensions are almost exactly the same as those of
the painting in Winterthur (Plate 83). It has been suggested
by K. E. Maison that these figures are probably fleeing from
a fire.

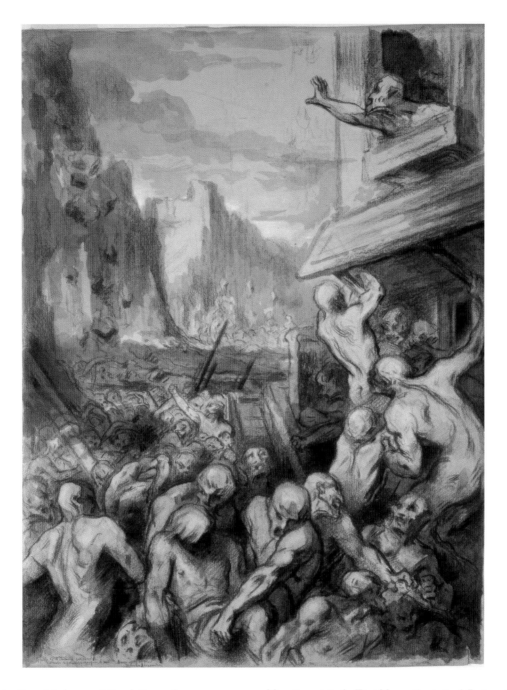

86 *The Destruction of Sodom* or *A Revolutionary Scene*
OXFORD, Ashmolean Museum. c. 1850? Charcoal,
watercolour and gouache 58 x 43 cm. Unsigned. Inscription
left by Arsène Alexandre: Sketch by H. Daumier which came
from his studio at Valmondois, acquired from Widow
Daumier in 1891 [February], Arsène Alexandre. [Esquisse de
H. Daumier provenant de son atelier de Valmondois et
acquise de Mme Vve Daumier en 1891 [février], Arsène
Alexandre.]
Apparently this drawing may have been intended as an
illustration for a history of France by the great historian
Henri Martin. Martin's *Origins of France from the First*
Migrations up to the First Mayors [*'maires*] *of Paris*, published
posthumously in 1891, the year Alexandre acquired this
drawing, may have been the book for which it was made,
although nothing by Daumier has been recorded in this or
any other work by Henri Martin. Two companion drawings
(London, private collection; and Moscow, Pushkin Museum)
show revolutionary scenes, which recall Daumier's painting
of c. 1849, *Revolutionary Scene*, destroyed in Berlin during the
Second World War. The composition of this drawing is not
unlike the large painting *We Want Barabbas!* (Plate 19) and the
style of naked figures recalls Daumier's relief *The Emigrants*
(Plate 84).

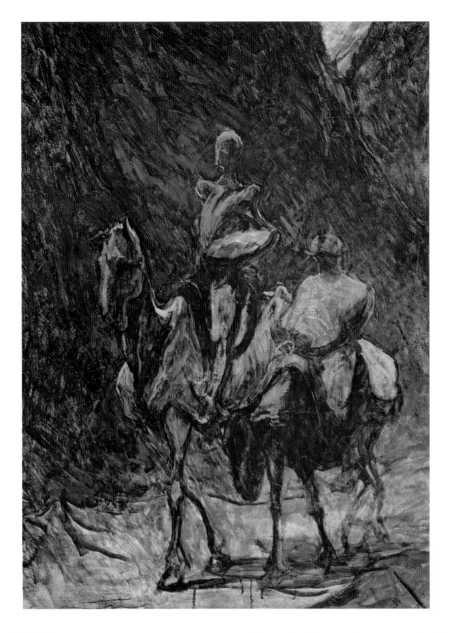

87 *Don Quixote and Sancho Panza*
LONDON, Courtauld Institute Galleries. c. 1870–72.
Oil on panel 100 x 81 cm. Unsigned.
One of Daumier's last paintings, this panel shows the artist outlining the principal forms in a thick, lighter-tone pigment, a technique which appears in another late oil, *The Painter in Front of his Picture* (Plate 43). Here the design of Don Quixote himself parallels that of similar oil studies, notably the brightly-coloured *Don Quixote* in Munich (Neue Pinakothek) and the early *Don Quixote Going to Camacho's Wedding* (Boston, Paine collection) which the artist exhibited at the Salon of 1850. This panel is the third largest *Don Quixote* painting Daumier ever attempted (see Plate 92). The two figures had by now become standardized personalities but are surrounded by dramatically steep mountains. The surface of this panel is covered with dry sketchy ribbons of paint. Daumier obliterated the sky; the mountains seem to close in and the two figures move near to the picture plane, although few identifiable features emerge from the nervous brushwork on their faces and bodies. Characteristic details are here reduced to cryptic squiggles. Daumier was nearly blind when he painted this picture. He left it incomplete, and the tones have probably darkened. Nevertheless, it is now regarded as one of his most striking works, a point perhaps confirmed by the existence of an accomplished forgery in a Swiss private collection.

DON QUIXOTE

The first part of Miguel de Cervantes's novel *Don Quixote* appeared in Spain in 1604, and translations of it in English and French were already circulating by 1614 when the second part was written. In 1948 Professor Jean Seznec traced fifty-two French translations of the book made between 1614 and 1934. Even this list is not necessarily complete. Many illustrations to the story also appeared in France; the earliest, dating from the middle of the seventeenth century, were of orthodox design, using the hero's madness as a source of humour. In *Don Quixote*, an elderly gentleman of La Mancha in northern Spain reads too many books about mediaeval chivalry and is deluded into thinking that he too is a knight-errant. Setting off to find noble adventures, he encounters only ridicule and incredulity. Parts of the book are very violent: Don Quixote is beaten many times, he is driven into the mountains (Plates 87, 91 and 92) and his books of knight-errantry are burnt by the barber and the local priest (Plate 88). At the turn of the eighteenth century this fictional character was no longer a well-loved literary buffoon, but became both monumental and pathetic. In the nineteenth century he emerged as a tragic hero. Illustrations to the story, produced by artists as diverse as Picart, Cochin, Boucher, Fragonard, Corot and Doré, all reflect this changed interpretation. Daumier perhaps created the most tragic and memorable images of the two main characters; Don Quixote himself, a long emaciated figure riding his equally emaciated horse Rocinante, contrasts with his 'squire', the rotund Sancho Panza, mounted on an ass. Both figures recall the riders from Daumier's paintings of fugitives and emigrants (Plates 83 and 85), which are set in landscapes as wild and abstract as those which surround Don Quixote (Plate 87).

From the late 1840s until, probably, the mid-1850s Daumier made drawings and paintings of riders which may derive from mounted figures on a classical frieze (Plates 65 and 66), but for the *Don Quixote* series he deliberately designed an unrealistic horse and rider, possibly to preserve a sense of the isolation of the two principal characters. They are rarely shown in the company of other figures in the novel. Daumier mainly chose to illustrate the first section of the story in which Don Quixote and Sancho Panza wander alone in the Sierra Morena (Plates 87, 91 and 92). Occasionally he made separate studies of each protagonist (Plate 88). The epic quality of Daumier's conception was not unique in the history of *Don Quixote* pictures: drawings by Fragonard made Don Quixote

into a far more heroic personality than was originally described by Cervantes, while Gustave Doré, who illustrated the 1863 Viardot edition of the novel, reduced the two famous characters to tiny, toy-like creatures moving across an almost surreal land of vast peaks encircled by clouds. While it is impossible to discover how well Daumier knew such illustrations, he evidently shared his fellow-artist's interest in the subject's general appeal.

Don Quixote paintings appeared in the Salon throughout the nineteenth century. They too generally took subjects from the first part of Cervantes's story. Sometimes, however, the painters depicted amusing incidents as a way of attracting attention; a practice exemplified by the obscure artist Penguilly l'Heridon whose work entitled *Don Quixote Seeing Sancho Panza Tossed in a Blanket* drew lavish praise from Etienne Délécluze in his review of the Salon of 1849 in the *Journal des Débats*. Sometimes a popular theme emerged from imaginary depictions of Cervantes himself: another very obscure artist, Thollot, had his painting *Miguel Cervantes Reading 'Don Quixote' to his Friends* accepted at the Salon of 1853. Daumier himself sought academic success at the Salon of 1850 with *Don Quixote Going to Camacho's Wedding* or *Don Quixote in the Mountains* (Boston, Paine collection), but he rejected, on the whole, any anecdotal qualities in his own representations. He probably began to sketch *Don Quixote* even before 1850, making his last paintings of the subject in the early 1870s when going blind (Plate 87); almost thirty known paintings and thirty-five drawings as well as numerous forgeries have survived, making *Don Quixote* one of the longest-running and most frequently treated subjects of Daumier's career.

(opposite left)
88 *Don Quixote Reading* (*Don Quixote lisant*) or *Man Seated Reading in an Armchair* (*Homme assis lisant dans un fauteuil*) or *The Prisoner* (*Le prisonnier*)
CARDIFF, National Museum and Gallery. Late 1860s. Oil on canvas 78·5 x 63·5 cm. Initialled bottom right: h.D.
A scene which does not correspond precisely to any in the story, in nevertheless introduces an important event in the first part of Cervantes's novel: the burning of Don Quixote's books (Chapters VI and VII). Absorbed in his masterpieces of chivalry, the hero fails to notice the village priest and barber peeping through the door. These characters decide that destroying Don Quixote's library of chivalrous romances is the only cure for the knight's

madness. A small painting of the same subject by Delacroix (Germany, private collection) may have provided Daumier with a source of inspiration for this theme. Delacroix's work, begun in 1824 and finished and sold in 1825, appeared at four subsequent sales in Paris during Daumier's lifetime. In 1843 it fetched 100 francs and then reached 400 francs eleven years later in January 1854 at Durand-Ruel's gallery where Daumier might have seen it. In 1869 it was sold again for 6850 francs and in April 1875 for 6200 francs. Daumier himself exhibited a finished version of this subject (Melbourne, National Gallery of Victoria) at Durand-Ruel's gallery in 1878, a much smaller work than this, which shows Don Quixote in more cramped surroundings. In the finished version the hero is clothed, whereas here he seems

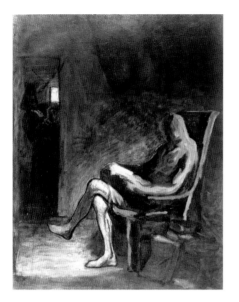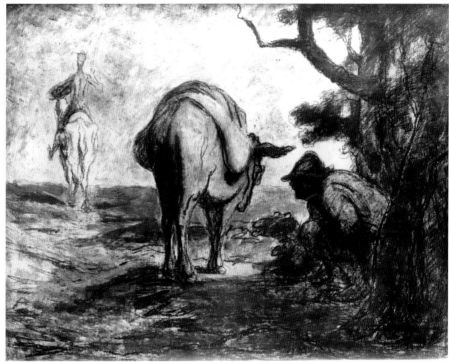

to be naked, and its composition generally is closer to Delacroix's picture. Daumier often liked to repeat favourite pictures and even made tracings from his own original designs (see Plate 60). A tracing of the Melbourne picture, now in New York (Solman collection) suggests consequently that this unfinished work may well postdate the composition in Melbourne. In the Cardiff version, the technique of laying dark lines over thick areas of paint in the background is consistent with the artist's late pictures, as is the abstract, anonymous drawing of the room and figures. In fact the identification of this as a *Don Quixote* subject was not made until 1952. Originally in the collection of Edgar Degas, the sketch appeared in Paris at the Degas sale held in March 1918, where it was acquired for the Welsh collector Gwendoline Davies by the dealers Bernheim-Jeune, and it was then known by its two other titles.

(top right)

89 *Don Quixote and Sancho Panza*

FRANCE, private collection. c. 1864–66. Oil on panel with some pencil drawing underneath Rocinante 24 x 31·5 cm. Unsigned.

Edmond de Goncourt recorded '. . . a lively grisaille by Daumier, portraying a ridiculous Don Quixote . . .' on 21 August 1893 when examining the art collection belonging to the photographer Nadar. This is probably the same picture, and one which interested Goncourt sufficiently for him to recognize it again when it appeared in Nadar's sale on 24 November 1895. In his diary Goncourt noted that Daumier's painting 'fetched scarcely more than a hundred francs'. Despite the writer's surprise this was in fact quite a good price for an unfinished oil work by Daumier in the late nineteenth century. In the previous year, 1894, after the death of the artist's wife, the whole of Daumier's studio was auctioned off for only 1500 francs. This little work actually represents one of the artist's most complicated developments of the *Don Quixote* theme. A pen and wash drawing (Switzerland, Remarque collection, on loan to the Kunsthaus, Zürich) shows Daumier's first preparation of the composition. There are two tracings taken from the drawing: one in Buenos Aires which repeats the whole design, and one in Paris of Don Quixote, Rocinante and the ass. This panel still bears part of the pencil drawing which transferred the design from the tracing, a preliminary effort which suggests that Daumier planned to construct an ambitious work but characteristically never completed it. The panel's 'ridiculous' subject, described by Goncourt, has never been identified. It may represent the famous incident in Part I, Chapter XX, in which Sancho Panza, during an all-night vigil, removes his trousers in order to relieve himself, hoping to be unnoticed by Don Quixote. However, overcome by the appalling smell, the knight orders his squire to leave him and stand at a distance.

123

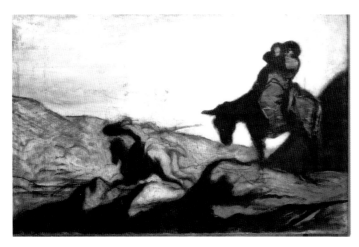

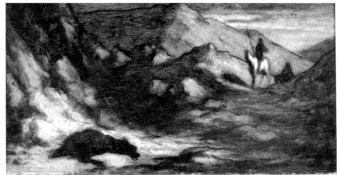

(above left)

90 *Don Quixote and Sancho Panza in the Mountains* (*Don Quixote et Sancho Panza dans les montagnes*) or *Don Quixote Charging at Sheep* (*Don Quixote courant les moutons*)

LONDON, National Gallery, c. 1860–64. Oil on panel 40·5 x 64 cm. Initialled right: h.D.

This scene in Part I, Chapter XVIII of the book shows how Don Quixote, despite the horrified protests of Sancho Panza, charges a flock of sheep mistaking it for an army. Daumier himself apparently gave this picture its title, although no sheep are visible. A more finished version, now in New York (Payson collection), became Daumier's greatest commercial success when he sold it in 1876 to Madame Bureau for 1500 francs. In 1878 the New York picture was one of five *Don Quixote* paintings exhibited at the artist's one-man exhibition and its popularity was reaffirmed in 1927 when it fetched 1,300,000 francs at the Bureau sale, the largest sum ever paid so far for a work by Daumier. This sketch has had a less spectacular career although it is, in some ways, a more interesting composition. Painted in thick, flat wedges of three main colours, blue-grey, light brown and dark brownish-black, the pattern of the whole design divides up into distinct segments. The black shadows in the foreground have little to do with the figures or their surroundings, but instead form their own self-contained patterns over the mountains and beneath the hooves of Rocinante and of Sancho's ass. There is an oil study in Paris of Sancho Panza (private collection) and an ink drawing of the complete subject, also in Paris (Roger-Marx collection).

(above right)

91 *Don Quixote and the Dead Mule*
(*Don Quixote et la mule morte*)

OTTERLO, Rijksmuseum Kröller-Müller, c. 1860–64. Oil on panel 23·5 x 45 cm. Unsigned.

This is a preparatory sketch for a canvas (New York, Metropolitan Museum of Art) which Daumier exhibited in 1878 when it belonged to the painter Daubigny. This version probably antedates the New York picture by several years although the two works possess almost the same dimensions, the New York picture being slightly larger (24·8 x 46·3 cm.). Two tracings of the composition on both sides of the same piece of paper (formerly Paris, Loncle collection) indicate the artist's extensive examination of this arrangement of the design. On the reverse tracing Daumier filled in sections of the mountain background with a blurred, chalky hatching to create a chequer-board effect. The distant figure of Don Quixote, reduced in size, exaggerates the feeling of distance; the receding mountain road slants across the picture to a raised vanishing point, and the heavy abstract shadows give this work a technical similarity to the oil sketch of *Don Quixote Charging at Sheep* (Plate 90) in London. Both sketches may have been made at the same time. This scene comes from *Don Quixote*, Part I, Chapter XXIII, which often formed the basis for Daumier's most experimental compositions (Plate 92).

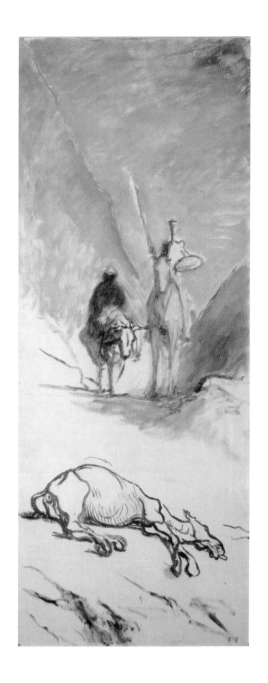

92 *Don Quixote and the Dead Mule*
(*Don Quixote et la mule morte*)
PARIS, Musée du Louvre. 1867. Oil on canvas
137 x 59 cm. Unsigned.

Don Quixote and Sancho Panza have fled into the
wilderness of the Sierra Morena after setting free a gang of
convicts, condemned to the galleys. Sometimes described
mistakenly as a wash drawing, this very abstract design is
reduced to thin contours and only one or two contrasting
tones. It is Daumier's largest *Don Quixote* painting, and may
owe its unusually foreshortened perspective to its having
been a decorative panel in the vestibule of Daubigny's
house. Paired with a work by Corot (Cincinnati, Cincinnati
Museum, 1868) this work recalls some of Corot's own steep,
sparely painted pictures of the 1820s, 1830s and 1840s. A
landscape such as the *Villa Barberini* (Paris, Musée du
Louvre) or the classical *Diana and Actaeon* (Metz, Musée des
Beaux-Arts) shows how Corot developed similar sparse,
vertical designs. Despite this, Corot's companion painting of
Don Quixote is quite unlike that of Daumier and sets the
knight and Sancho Panza in a landscape resembling
Barbizon. Daumier himself was obviously interested in the
possibilities of this scene because he had already depicted it
several times (Plate 91). There is no known drawing.

BIBLIOGRAPHY

Any history of Daumier is limited by the scarcity of material and, inevitably, is quickly out of date as new material comes to light and pictures change hands or disappear completely. Despite these drawbacks there are a number of excellent biographies. Those which have a specific bearing on this book are listed as follows:

Jean Adhémar, *Honoré Daumier*. Paris, 1954.

Arsène Alexandre, *Honoré Daumier, l'homme et l'oeuvre*. Paris, 1888.

R. Escholier, *Daumier et son monde*. Paris, 1965.

Pierre Georgel and Gabriel Mandel, *Tout l'oeuvre peint de Daumier*. Paris, 1972.

Howard P. Vincent, *Daumier and His World*. Evanston, 1968.

Contemporary Accounts of Daumier's Life and Work:

Théodore de Banville, *Mes souvenirs*. Paris, 1882.

Charles Baudelaire, *Salon de 1845*, May 1845; 'Quelques caricaturistes français', first published in *Le Présent*, 1 October 1857 and reprinted in *L'Artiste*, 24–31 October 1858. Both reprinted in *L'art romantique et autres oeuvres critiques* (ed. Henri Lemaître), Paris, 1962.

Philippe Burty, 'Enterrement de Daumier', *République Française*, 15 February 1879.

Champfleury (Jules Husson or Jules Fleury), *Histoire de la caricature moderne* (vol. V of a longer work on the history of caricature 1865–90). Paris, n.d.

Champfleury (Jules Husson or Jules Fleury), *Les Excentriques*. Paris, 1852. A study of strange characters, with a dedication to Daumier.

Louis-Emile-Edmond Duranty, 'Daumier', *Gazette des Beaux-Arts*, 2ème sér., vol. XVII, 1878.

H. Garnier, 'Daumier' and 'Les obsèques de Daumier', *Le Voltaire*, 13 and 15 February 1879.

Edmond and Jules de Goncourt, *Journal de Goncourt: mémoires de la vie littéraire*. Paris, 1887–96.

Louis Leroy, review of Daumier's exhibition, *Le Charivari*, 1 May 1878.

Camille Pelletan, 'Daumier', *Le Rappel*, 14 February 1879.

Unsigned article, now known to be by Castagnary, and also a review of the exhibition, *Le Siècle*, 25 April 1878.

Specific Works by Daumier:

E. Bouvy, *Daumier, l'oeuvre gravé du maître*. Paris, 1933.

S. L. Faison, *Honoré Daumier, The Third Class Railway Carriage in the Metropolitan Museum of Art, New York*. New York and London, n.d.

Maurice Gobin, *Daumier sculpteur 1808–1879*. Geneva, 1952.

N. A. Hazard and Loÿs Delteil, *Catalogue raisonné de l'oeuvre lithographié de Honoré Daumier*. Paris, 1904.

Bernard Lemann, 'Daumier and the Republic', *Gazette des Beaux-Arts*, 6ème sér., vol. XXVII, 1945.

K. E. Maison, *Honoré Daumier; Catalogue Raisonné of the Paintings, Water Colours and Drawings*. London and Paris, 1968.

Henri Marceau and David Rosen, 'Daumier, Draftsman Painter', *Journal of the Walters Art Gallery*, vol. III, 1940. This article is a particularly revealing technical analysis of a number of Daumier's paintings, including 'The Third-class Railway Carriage' series.

Daumier's Patrons and Prices:

Baltimore, Baltimore Museum of Art, exhibition catalogue, *George A. Lucas Collection*, 12 October-21 November 1965.

Jean Cherpin, 'Le dernier carnet de comptes de Daumier', *Revue Municipale*, 3ème sér., no. twenty-nine. Marseilles, 1956.

John Ingamells, *The Davies Collection of French Art, Cardiff, National Museum of Wales*. Cardiff, 1967.

O. Larkin, *Daumier in His Time and Ours*. Katherine Asher Engel Lecture, Smith College, Northampton, Massachusetts, 1962.

Daumier Exhibition Catalogues:

Paris, Bibliothèque Nationale, *Daumier lithographies, gravures sur bois, sculptures*, 1934.

Paris, Bibliothèque Nationale, *Daumier, Le peintre graveur*, 1958.

London, Arts Council, *Daumier Paintings and Drawings*, 14 June-30 July 1961.

Hamburg, Museum für Kunst und Gewerbe, *Honoré Daumier und Sein Kreis*, 19 October-21 November 1961.

Cambridge (Massachusetts), Fogg Art Museum, *Daumier Sculpture, A Critical and Comparative Study*, by Jeanne L. Wasserman, Joan Lukach and Arthur Beale, May–June 1969.

The Literary Background:

Eugène Hatin, *Bibliographie historique et critique de la presse périodique française*. Paris, 1866.

Stanislav Osiakovski, 'The History of Robert Macaire and Daumier's Place in it', *The Burlington Magazine*, vol. C, no.668, November 1958.

Jean Seznec, 'Don Quixote and his French Illustrators', *Gazette des Beaux-Arts*, 6ème sér., vol. XXXIV, 1948.

Jean Seznec, *John Martin en France*. London, 1964.

Charles Beaumont Wicks, *The Parisian Stage*. University, Alabama, 1950.

The Historical Background:

Henri d'Almeras, *La vie Parisienne sous la règne de Louis-Philippe*. Paris, n.d.

Henri d'Almeras, *La vie Parisienne sous le Second Empire*. Paris, n.d.

Charles Baudelaire, 'Le peintre de la vie moderne', *Le Figaro*, November–December 1863.

Shepard Bancroft Clough, *France, A History of National Economics 1789–1939*. New York, 1964.

Pierre Dauzet, *Le siècle des chemins de fer en France 1821–1938*. Fontenay-aux-Roses, 1948.

Alistair Horne, *The Fall of Paris, the Siege, and the Commune 1870–1*. London, Melbourne and Toronto, 1965.

Alexandre Ledru-Rollin, *Mémoire sur les événements de la Rue Transnonain*. Paris, 1834.

Georges Matoré, *Le vocabulaire et la société sous Louis-Philippe*. Paris, 1967.

J. Murray, *Handbook to Paris*. London, 1866.

Léon Rosenthal, 'Les conditions sociales de la peinture sous la règne de Louis-Philippe', *Gazette des Beaux-Arts/Arts*, 4ème période, vol. III, 1910.

Jean Vidalenc, *La société française de 1815 à 1848*, vol. II: *Le peuple des villes et des bourgs*. Paris, 1973.

ACKNOWLEDGEMENTS

I would particularly like to thank Dr Peter Wexler, Chairman of the Department of Language and Linguistics at the University of Essex, for his patient kindness in elucidating for me the language of the captions of Daumier's cartoons; I am indebted also to Douglas Oliver whose knowledge of Rabelais contributed greatly towards the writing of the caption to *Gargantua*; I must also express my gratitude to David Jones, the staff of the National Museum of Wales and the staff of the Department of Prints and Drawings of the British Museum; finally, I acknowledge the invaluable help of Mrs Maureen Reid.

Photographs are reproduced by courtesy of the following, to all of whom sincere thanks are due: Art Institute of Chicago, Chicago; Ashmolean Museum, Oxford; Baltimore Museum of Art, Baltimore; Bibliothèque Nationale, Paris; British Library, London; British Museum, London; City Art Gallery and Museum, Glasgow; Courtauld Institute Galleries, London; Courtauld Institute of Art, London; Detroit Institute of Arts, Detroit; Fogg Art Museum, Cambridge, Massachusetts; Graphische Sammlung Albertina, Vienna; Kunsthistorisches Museum, Vienna; London Borough of Hounslow; Maryland Institute, Baltimore; Metropolitan Museum of Art, New York; Minneapolis Institute of Arts, Minneapolis; Munch Museet, Oslo; Musée Carnavalet, Paris; Musée des Beaux-Arts, Lyon; Musée des Beaux-Arts, Marseilles; Musée des Beaux-Arts, Rheims; Musée du Louvre, Paris; Musée du Petit Palais, Paris; Musées Municipaux, Chartres; Museum Folkwang, Essen; Museum of Fine Arts, Boston; Museum of Fine Arts, Montreal; National Gallery, London; National Gallery of Art, Washington; National Gallery of Victoria, Melbourne; National Museum of Wales, Cardiff; National Portrait Gallery, London; Neue Pinakothek, Munich; Ny Carlsberg Glyptotek, Copenhagen; Ordrupsgaardsamlingen, Copenhagen; Philadelphia Museum of Art, Philadelphia; Phillips Collection, Washington; Oskar Reinhart Collection 'Am Römerholz', Winterthur; Rijksmuseum Kröller-Müller, Otterlo; Szépművészeti Múzeum, Budapest; Victoria and Albert Museum, London; Wallace Collection, London; Walters Art Gallery, Baltimore; Yale University Art Gallery, New Haven; Ets. J.E. Bulloz, Paris; Photographie Giraudon, Paris; Service de Documentation Photographique de la Réunion des Musées Nationaux, Paris; M. Robert Houette; M. Georges Kriloff; and Mr David Mower.

I must also thank those private collectors who wish to remain anonymous for kindly granting permission to reproduce works in their possession. In two cases the publisher has been unable, despite all efforts, to trace the owners of works reproduced in this book, for which he wishes to apologize.

For V.F.S.
SEQUITUR PATREM NON PASSIBUS AEQUIS